MUSES
FROM
CHAOS
AND
A S H

AIDS, ARTISTS,
AND ART

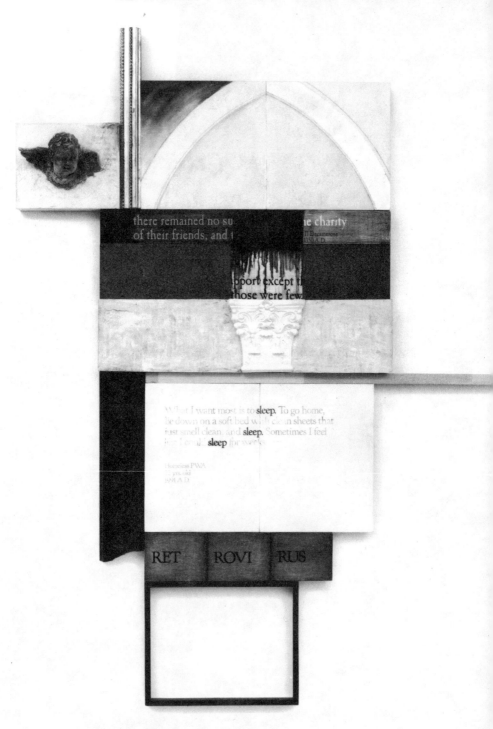

Robert Farber, *WESTERN BLOT NO. 9* (1991)
mixed media on masonite panels, 64″ × 46″

MUSES
FROM
CHAOS
AND
A S H

AIDS, ARTISTS, AND ART

Andréa R. Vaucher

GROVE PRESS

NEW YORK

Published by Grove Press
A division of Grove Press, Inc.
841 Broadway
New York, NY 10003-4793

Published in Canada by General Publishing Company, Ltd.

Library of Congress Cataloging-in-Publication Data

Vaucher, Andréa R.
 Muses from chaos and ash : AIDS, artists, and art / by Andréa R. Vaucher.
 p. cm.
 ISBN 0-8021-1413-X
 1. Artists—United States—Interviews. 2. Artists—United States—Attitudes. 3. AIDS (Disease)—United States—Patients. 4. Arts, Modern—20th century—United States. I. Title.
NX504.V38 1993
700'.92'27309049—dc20 92-588
 CIP

Manufactured in the United States of America

Printed on acid-free paper

Designed by Virginia Norey

First Edition 1993

10 9 8 7 6 5 4 3 2 1

To my parents,
for encouraging my own creative process

CONTENTS

What you finally come back to is that the most therapeutic thing is to just proceed with your life. One day at a time, I wake up and make another motorcycle jacket.

—Kenny O'Brien
(designer)

MUSES
FROM
CHAOS
AND
A S H

AIDS, ARTISTS,
AND ART

PROLOGUE

I was driving up to Woodstock to visit my friend Kenny O'Brien. A time bomb, he had said on the phone.

AIDS has ravaged the international creative community, leaving a torrent of interrupted dreams and unfinished personal canvases in its wake. During the first week of December in 1991, a bell tolled every ten minutes in art galleries and museums around the world, marking the rate at which people were dying of AIDS.

The bell was part of Day Without Art, a time of celebration and mourning that takes place every December first and coincides with World AIDS Day. It is the international art world's annual tribute to those in the performing and visual arts communities who have been lost to AIDS. Galleries shut down for the day, theaters dim their marquees, museums remove or cover key pieces of art in their collections, television stations interrupt their broadcasting; one year, even the New York City skyline went black.

In 1991, December first fell on a Sunday, a day when galleries and other businesses are usually closed anyway. This dilemma motivated New York painter Robert Farber to create *Every Ten Minutes,* a continuous audio cassette of the tolling of a solitary church bell. Like so many other artists around the world, he wanted to be certain that Day Without Art would, as it had the two previous years, make a powerful statement.

Some galleries wired their sound systems so that the bell reverberated out into the street all day Sunday; others played the tape the entire last week of

November. As with nearly every challenge of the AIDS crisis, an obstacle merely had inspired greater creativity. Day Without Art was an unprecedented success.

In a way, that's exactly what this book is about: creativity born from crisis. Creative fire finding its spark in the belly of chaos. Creation rising like a phoenix from the ashes.

This book is not about the artists who have died from AIDS. That story will be told through their legacies. This is not the history of people being stolen from us, at a rate much faster than every ten minutes now. This book is about creative spirit and strength, told in the voices of artists from the worlds of dance, theater, film, literature, design, and the visual arts. Artists who are living every hour, working every day, year after year, with this virus.

I was driving upstate to visit my friend Kenny O'Brien. I was driving into the dusk, into a place that was neither night nor day. A time bomb, he had said on the phone.

I don't remember who showed me that Keith Haring drawing. It was right around the time Haring came out about having AIDS. It was a picture of a "radiant child," one of those crawling babies surrounded by sunbeams that Haring had painted everywhere from New York City subway stops to the Berlin Wall. This one, though, had grown a giant tumor on its back. Later, studying Haring's work closely, I realized how rapidly he had matured as an artist. AIDS had given him the courage to seize certain ideas and reject others in a breath. The line was bolder, more assured; the subject matter, as in the *Apocalypse* series he had done in collaboration with William Burroughs, was more daring. And despite his health, Haring, already an incredibly productive artist, had become even more prolific.

I wanted to explore this subject more thoroughly. From my personal experience, from my own friends who were artists and HIV-positive, I knew this creative transformation extended far beyond the visual arts. Writing an article on AIDS and the artist for *Areté* magazine, I entered a labyrinth of talent hit by the AIDS crisis, artists whose work and lives had been profoundly affected. There were the visual artists who had already died, like

photographer Robert Mapplethorpe and Chicano painter Carlos Almaraz, whom I included in the article. But there were artists in other fields who had died or who were sick—the Joffrey Ballet's Edward Stierle, Argentine playwright Copi, designers Willi Smith and Halston—who probably would never have the chance to tell their creative story, to look at and reflect upon the sum of their work. And there were the many artists who were still living with AIDS or HIV infection, some who consciously used this in their work and others who did not; some who had brilliant careers, others just starting out. This was the group I chose to focus on for this book. These artists would, I hoped, describe the journey, in their own voices.

I was driving up to Woodstock to visit my friend Kenny O'Brien. He was a clothing designer. A time bomb, he had said on the phone.

The work emerging from this epidemic will change how historians and future generations view art in the context of the late twentieth century. When we look back on fourteenth-century European art and the Renaissance, we now realize the significance of the architecture, sculpture, frescoes, and writings that were directly inspired by the Black Death. Looking at the art of that period, much of which was unfinished since so many artists died suddenly in the middle of important works, we can see the overwhelming effect of that epidemic on the whole of European society. Similarly, the discernible shift in emphasis from form to content in art today—not just in the work of people personally affected by AIDS—may be attributed to the force with which the AIDS crisis, like the Black Death before it, has shaken the collective psyche down to its creative bones. This late-twentieth-century AIDS art will undoubtedly provide significant keys to understanding the culture and society of our time in a framework much broader than an artistic one.

I was driving up to Woodstock to visit my friend Kenny O'Brien. A band of daylight at the horizon defied the night's approach. A time bomb, he had said on the phone.

Kenny O'Brien was a friend. Many of the other artists I talked with were strangers—sometimes friends of friends—yet we sat face-to-face, discussing

subjects rarely broached even between intimates. In the beginning, there were specific questions I hoped would be answered: Is there a change in patterns of thought, fantasy, imagination, and inspiration? When AIDS implodes in the body of an artist, how loudly does it resonate in his body of work?

After I spoke with a couple of the artists, I realized there could be no set strategy for the interviews. I also quickly understood that no pat hypotheses or theories would emerge. I was speaking with a select group of artists chosen from those I could find who were willing to come out about their medical status. I tried not to be manipulative. I didn't want the artists to try to fit into a conception of something they imagined I wanted them to be. The way artists deal with AIDS in their work is as varied as the people who are infected with this virus.

The more people I interviewed, the less uncomfortable I felt. As these men and women fearlessly examined their lives and their art, I became less awkward, less self-conscious about how I worded my questions. Their courage and willingness to shatter denial and confront the truth forced me to face things about myself. The apprehensions we all feel—fear of meeting a new person, of not being smart enough, of not having something interesting to say, of our not liking each other—were put aside. I learned about bravery from these artists; I put down my notes and became even more engaged. I tried to be a warrior.

I aimed to be as fearless in my interview process as these artists were in their work. In their lives. I asked the harder questions. Questions about death and dying. Was there a progression toward spirituality in the work? Did sexuality remain in their art? Was sex still a part of their lives?

I was driving up to Woodstock to visit my friend Kenny O'Brien. A time bomb, he had said on the phone. Come this weekend.

The conversations were powerful. I went wherever our talks took us whether I was familiar with the subject or not. I often felt vulnerable when they led me into difficult emotional territory. But I followed. We began to trust each other. The interviews lasted hours and rambled through art,

psychology, politics, and philosophy. Sometimes, uncharacteristically, I spoke about myself, shared my own secrets. In doing so, I realized that every time we speak our truth, we affirm ourselves and feel more alive. That was when I understood that these conversations were about living, not about dying.

It doesn't matter if you are not familiar with all the artists here. (In the back of the book, however, there is a brief biographical entry for most of them.) This is not an analytic study of work and performance. You will not need accompanying pictures, films, or books to understand what these men and women are saying. When an artist does address a specific piece, the work is described, but usually our talks focused on the creative process itself.

Speaking with these artists who were HIV-positive or who had AIDS was a profound experience, a privilege. As they heroically explored their lives and their deaths, they never ran from their feelings, not even the most painful ones. When one of the artists whom I had interviewed died, I almost abandoned the project. Then I remembered what he had taught me about accepting life on life's terms.

This project became more than a book. It became a mission. I discovered that I am telling this story because I am here, alive, to tell it.

I was driving up to Woodstock to see my friend Kenny O'Brien. I was driving upstate to see my friend.

When I pulled into the driveway, he was leaning over the second-floor balcony. The sunset turned the dense green hills as black as his leather jacket.

A time bomb, he had said on the phone.

We sat at a wooden table, overlooking the valley, surrounded in darkness. The tip of his cigarette glowed orange as he brushed the fireflies from the air between us.

We talked until sunrise. . . .

ARTISTIC
EXPLORATION

I do not seek, I find.

—*Pablo Picasso*
(painter)

Sitting that night with my friend Kenny O'Brien on the balcony of the house he designed after finding out he was HIV-positive, we spoke about his work. There was his design business featuring one-of-a-kind leather clothing studded with crystal and metal, the house and landscaping, and, now, an idea for a book. I saw how AIDS had increased his creative energy. Despite the intermittent fatigue, despite the Kaposi's sarcoma lesions, he was driven.

How does AIDS intensify the already intricate artistic process?

The creative process is a hero's journey. The artist travels inward, drawing raw material from within. Then he attempts to organize and make sense of it all. Art is the orchestration of disorder, the creation of harmony out of chaos. When an artist is living with AIDS, this quest becomes amplified. The

path becomes a double helix that merges the spiral of the artist's creative search with the gyre of life with HIV or AIDS. Many of the challenges any artist battles in bringing his work to life—isolation, anger, frustration, despair, doubt—are the same ones that test a person with AIDS.

Does this double passage heighten emotion and feeling? If so, how does this increased emotional level manifest itself in the work? Do the trials of the artist become even more imposing?

"Dangerous and fertile" is how writer Irene Borger describes the creative depths. Borger, who is AIDS Project Los Angeles's artist-in-residence, teaches a writing workshop for people living with HIV and AIDS. "There is this long period of darkness, where the birth is going on, but you don't know that. You've left behind your old state. With each problem you don't know what you're capable of, you feel like you're starting up the mountain again."

Borger might have been describing the AIDS journey, so similar are the emotions evoked in the artistic process to those encountered on the path of this illness. Testing HIV-positive, recovering from an opportunistic infection, the physical ups and downs, and the starts and stops provoke fear, pain, sometimes even relief. Does the artist with AIDS feel in familiar territory? As though he has been here before emotionally? And if so, does this familiarity alleviate his fear of the unknown?

Does the reality of testing HIV-positive strengthen inspiration and imagination? Is AIDS named in the work or does it somehow come through obliquely?

Certainly AIDS was apparent in photographer Robert Mapplethorpe's self-portraits as his countenance changed from sexy defiance to poignant dignity. In the final pictures he is an oddly elegant man, wise and old before his time. One of them portrays Mapplethorpe, all in black against a black background, gripping his cane, the handle a silver skull. His head appears disembodied, as though floating in timeless black space, in much the same way Mapplethorpe photographed an earlier AIDS fatality, Roy Cohn.

Painter Robert Farber created a collection of imposing wall sculptures, the *Western Blot* series, named after a test for HIV antibodies. In textured compositions that mix elements like wood, plaster, and canvas, Farber takes

quotes from sources as disparate as Boccaccio and homeless people with AIDS (PWAs) and combines them with blowups of medical imagery like the AZT molecule. By using lines from the *Decameron* with moldings and geometric shapes that evoke Italian architecture from the fourteenth century, Farber juxtaposes the AIDS crisis with the Black Death.

Obviously not every artist who tests HIV-positive feels compelled to use AIDS in the content of his work, but are distinctive creative patterns emerging? Does work become less abstract?

"There has been an explosion of content-driven art," stated Patrick O'-Connell, director of the support group Visual AIDS and himself HIV-positive, speaking about work being made by artists living with AIDS. "The autobiographical content and general commentary are visceral, very potent, and really disturbing, especially on the tail of eighties postmodernism, which was about no content. A new work is emerging."

What can we learn from this work? Since art is also a transfiguration of events, a way in which the viewer's mind is elevated to perceive things in a different light, can this work change the way society feels about this crisis? Can this art inspire new compassion?

Besides shifting our perception, art can give us keys to the chaos that results when a worldview is shattered, as it has been with AIDS. It is the traditional role of the artist to unearth information not readily apparent to the rest of us. "The image I had," stated Irene Borger, describing the artist's descent below the conscious plane, "was of diving deep down inside, going all the way down until you find water, your own water, which is the collective water."

Is there something in this "collective water" that we all need to know, that we can apply to our time, to our own lives?

DAVID WOJNAROWICZ
(painter)

After testing positive, I went into a fairly dark depression and out of that came this sense of emptiness and grappling. You know, making work always helped me to survive, whether it was as a kid making drawings or as a young adult becoming serious and trying to publish things or get people to look at the work. It's always been my communication. I have a shy streak. I'm not a very social person but I can make things and that's always been my primary source of communication. For a while, it was very scary to think that I wouldn't make anything ever again.

I think anybody who is impoverished in any way, either physically or psychically, wants to build rather than destroy.

All my life I've gone through psychological, emotional, and physical processes and some of it was really difficult. The first couple of years after I got off the street, I started to make drawings, make writings. They were awful, but I did them anyway. I've realized in the last eight years that a lot of that process was to peel away all the defenses that I had built up living in the society, growing up in the society, and not having a voice in the society because I was either underage or because I lived in socially acceptable forms of brutality. I built up this wall between myself and the people around me in order to survive. All my work has been about peeling away those defenses and laying everything that I consider, everything that I witness, everything that I see, out on the table. It's been a gradual process. If you were to look at things of mine from my early twenties and then look at what I'm doing now—it was a genuine, constant

process that took years to name things that there's so much social pressure not to name. Over time it's been an insistence of mine to develop further and further, to name the illusion or name what's inside the structure that most people seem to be completely unaware of or too frightened to look at.

I think making things is about stepping outside of the world. It is about taking a distance from the weight of society or the weight of existence. It involves fantasy; it allows a mental drift. When you're really hooked into something, it's the closest thing you can get to flight. I know that what literally saved my life was being able to make things or explore things. That took me out of the world that I found insufferable and put me in a place that gave me an enormous amount of relief, whether it was drifting, whether it was sanity, whether it was any of those things involving motion or whatever.

What I can't write, I paint and what I can't paint, I make in video and what I can't make in video, I make in still photography. It's a whole process of self-examination as well as examination of the social structure. The social structure, or my sense of living, is never not involved with all of the illusive things like dreams, like fantasies. I've come to believe, in recent years, that there is no separation between fantasy and reality. That lean something in what we call reality can create a physical effect, so I can't deny that it's there. Or something in fantasy may be a little more illusive or less physical. But thinking about the process of the brain, of the eye, all these things, I came to the point where I realized that vision, that stored moments of memory—it takes a fraction of a second for the eye to pick up something out of the moving environment and recognize it as something specific, but in that moment that thing has become a locked image, a coded image inside the brain. And fantasy is nothing more than that, too. It's just fragmentation of reality that we've pulled to-

gether and fit into composites. In the last year, it's been a big question to me whether or not there is a difference between reality and fantasy or whether they're all from the same source and all just made up of our perceptions given our environment or our experiences, or whatever. So to deal with reality in my work and to deal with fantasy in my work, for me there is no separation. It's like I collapse those walls. I collapse those walls in my writing, too.

Most people need to be told what things are in order to feel any comfort at all. I guess I do that process for myself. I try to look at what things are, or the fluctuations of what things are, in order to be able to be comfortable to the extent that I am in the world.

MARLON RIGGS
(filmmaker)

After I got sick, I began to think about what would happen with my life, where it would go, how long it would last, and what I would do with my work because of that. I had been working on *Tongues Untied* in my head before I got sick, but I really had no clue as to what it should be in terms of form, shape, aesthetics. I knew I wanted to do a documentary about black gay poets, because so much cultural expression from black gay men, particularly around the mid-eighties, was coming from poets. People were addressing issues of identity, shame, self-hatred, and the transcendence of internalized homophobia and racism through poetic form. For me, as a documentarian, I was piqued as to why poetry. Out of all the ways in which you can assert your identity in a world that views you with chronic, constitutional hostility, why poetry? For me it was intriguing to

do a documentary that could affirm both the existence of this cultural movement and the declarations of people who had formerly been silenced that they would no longer engage in the masking of their lives, they would no longer pretend to be invisible.

But I had no clear sense of how to connect discrete poems from different poets. In my mind it would almost be akin to an MTV piece—you could have rapid-fire non sequitur juxtapositions—but would it really add up to anything? And no way did I envision myself part of this work. I had been trained as a classic journalist documentarian, where as a reporter/producer you extract yourself from the story as much as you can. Of course, you never do, but you do hide behind the various masks of the objective journalist, and if you appear in the story, you play a very well defined role. None of your own subjective experiences or impressions, insights, values, or biases are explicitly played as part of the story. You are simply there as an interrogator to elicit from others. I know that is what I intended to do. I would have done the typically documentary thing, which is to have an assembly of people speaking about their work and their lives and their poetry. And I would have simply edited it together in some fluid, cogent way that hopefully might be moving.

After I got sick, I started to wonder, What am I doing here? All the subjects of this documentary—Essex Hemphill; Reggie Jackson; Craig Harris, who's now died; Joseph Beam, who's now died—have put their own lives on the line. They have affirmed the totality of who they are, including those areas of secret shame and self-loathing. They have spoken in frank, honest, and, I think, ultimately empowering ways, and yet here I was hiding behind this traditionalist mask of journalist documentarian, unwilling to confront my own life in a similar way.

As I contemplated my life in the hospital bed, watching an array of banal television programs, I began to let my mind roam

free. Also, as when anyone is confronted with the imminence of death, I considered the paths I had taken to reach this point and what I might do, if I lived longer, to justify my life. To justify the privileges I had enjoyed as someone educated in an Ivy League university, teaching at a top university with access to money as well as equipment. I realized I was in a very pivotal and unprecedented position to do something bold and risk taking without paying a price that others might in less secure positions.

I began to think about my life, and in that process, memories returned: yearnings for acceptance as an adolescent and as a child, the ways in which racism and homophobia entwined to strangle much of my life and nearly suffocate me. And I considered how I might begin to extricate myself and in the process, through my story, weave together many of these discrete poems so that there was a progression, a narrative unfolding that was more than simply one poem at a time. And, in the illumination of my own struggle around being black and gay and now HIV-positive, to connect to the communal struggle and to an historic struggle so that my story was not simply my story, but our story. And our story could be shared not simply within the confines of sexuality and sexual identity, but also deeply and powerfully within the whole struggle of African Americans for liberation and redemption and self-love. It was an epiphany in many ways to come to that.

ROBERT FARBER
(painter)

I was going to seminars and Body Positive, an HIV-positive support group, and I was hearing the AIDS lingo, and a phrase—"the window of opportunity"—hit me very hard. The window of opportunity is that period of time, that I am now in,

where one is relatively asymptomatic and T cells are stabilized. The idea is that it's an opportunity for early intervention that may pay off later. That was a very evocative phrase to me. It led me to start looking at illuminations—illuminated manuscripts—of the fourteenth and fifteenth centuries. These illuminations were like windows. You look into these gorgeous scenes.

As I was beginning to pull myself out of the despair that came with testing positive, I realized that basically the human condition is a tragic condition. Everyone dies alone. I no longer can bring myself to believe in the larger picture, which is what my abstract paintings were about, the larger picture in the sense of transcendence. But I have developed this idea that although I may not know what the point is, I think there is a point. Maybe living is about learning how to be genuine with yourself and with others. Which is hard. And even if I only manage ten minutes of genuineness a day, that's a good thing of its own. And I began to feel—and this was also because of my political involvement—basically optimistic about my own condition. In twenty years' time when the younger generation asks what it was like to live during these dark times, I would be able to say I used what voice I could to take a stand.

Three years ago I was doing only large abstract work, color fields. It was very impersonal and influenced by landscape. Then I got tired of all that, I wanted to change everything around artistically. In therapy I was exploring the dysfunctionalism of my family. I decided I wanted to explore nightmares that were always part of my experience, a horror I was always drawn to. And at the same time, I wanted to tell the story of what it was like to use drugs in the seventies and early eighties. So I started doing completely different work, figurative work. I tried to capture not only the horror of that kind of voracious pleasure seeking but the craziness of it. But intermingled with that were

also the personal demons that I was exorcising. I used very realistic figures, I quoted pictorially from Hieronymus Bosch and movie ads, I used my own photography, collaging it. It culminated with a major piece that I felt said it all: what it was like to be on drugs, the downtown scene and the pleasure and the sex and all the craziness of it. I was finishing this group of paintings when I first tested positive. I was just finishing that stuff up in Provincetown, where I always summered and painted, and that summer I became terribly sick.

I started reading Barbara Tuchman and found compelling parallels between medieval man's experience of the Black Death and AIDS today. There were so many equivalents: sociologically, economically, culturally, spiritually. All the Italian banks failed, there were growing numbers of homeless because of the famine which preceded the Black Death. Much of the hoo-ha of the art world of the seventies and the early eighties recalled events and activities that occurred during the Black Death. It was a really crazy time back then. There were these fringe groups that really went wild in much the same way that the Ivan Boeskys went wild or that the Danceteria crowd went wild. I think that a part of my thesis is that the rituals that people found themselves involved in are paralleled not only in this lust for money and power, but in the art itself. At a certain point in the art of the eighties, the line between observation and commentary and participation became blurred. There were artists who were trying to go beyond kitsch, beyond commodification, and they were glorifying it, they were celebrating it. They were involved in this danse macabre, sucked in by the very same thing they were supposedly commenting on—the commodification of our values.

❖

No matter how carefully I have established in my mind an image or an idea for a painting, when I am in the process of working, often those a priori images and decisions don't work themselves in. Often I watch the painting as it unfolds. I have to learn how to let go of whatever prior imagery or formal considerations I had made and let the painting happen how it happens. One of the things now that I'm doing differently is that I'm letting it happen more, rather than having so much control over the elements, the quotes, the formal configuration. I'm letting this subject matter of AIDS and the Black Death and death and illness reside in me more, with more availability. Before, I had a tighter hold on what happened on the canvas, there was less risk involved and it was born more out of fear. And the fear is, I don't want to be thinking about this subject matter, I don't want to be talking about this stuff. Where I am today is—I am this stuff. I'm also other things, but the most important part of my life and the largest part of my life right now is as an artist with HIV. And as I let that move in on me more deeply, the work comes out a little more freely and I feel less of this distance.

I'm much looser in my work. I used to have this attitude that every painting had to work, everything was always riding on anything. The stakes were so high. I was fighting my own inner Salieri syndrome: I'm mediocre so I've got to make everything a fucking masterpiece. Now I'm much freer. I let things be which otherwise I would consider unfinished. I don't want to just work with illuminated manuscripts as a reference. I saw multipaneled altarpieces as an influence so I got these Masonite pieces made. Since I'm also using molding and gold leaf and I'm cutting the wood myself, I'm having to learn the kind of craftsmanship that the Renaissance journeymen used to make these pieces. I have to learn what will work archivally on what surfaces and then

figure out by trial and error how to join the pieces, what kind of backing to use. I feel like I'm this apprentice journeyman. It's like puzzle solving.

I feel like because I came through this three- or four-month period of utter despair, there is a new kind of weight to my life. I've changed a lot of things. I now do only what feels comfortable and pleasurable. One of my goals is to live a life as stress-free as possible. And as an artist, what's built into the process, no matter how loose one is, is always a moment of incredible stress where I'll leave the studio feeling like a total failure. I know now though that it's a phase I will live through and come out the other side of. One of the hardest things to accept—and it plays a large role in my work—is living with uncertainty on a daily basis. The act of painting occurs in an environment of uncertainty, no matter how finite or preconceived a notion I have. And living with the uncertainty of my future healthwise has made it easier to withstand the inherent uncertainty in the creative process.

I'm coming back to something I'd left for many years—gestural painting. I think the gesture, the human gesture as it translates into a brushstroke, is a way of marking that I am here. This is my mark. I have showed up here today, this was me today. There's something very intimate and human about gestural painting. And how that juxtaposes against a more minimalistic or even medieval painting is cause for an interesting tension in the work.

KENNY O'BRIEN
(designer)

I went to my family and said, "I don't know whether I'm going to write a book, design clothing, shoot a film, or start photography again, but I have got to get into my creative process and it's not going to happen bartending." After I sold the first few leather jackets, they said, "Okay, we'll back you," and I designed the collection. I put the design table outside the tepee I was living in while I was building this house, and jackets started selling. I got a patternmaker, went to L.A., and sold fifty thousand dollars' worth of stuff. Everybody was raving. I thought, This is it, I have finally found my niche.

The clothes were getting better and better. Some were opulent, some were subdued; we were working with cut and I was starting to think about color. First it was all black and silver, silver studs on black leather, the whole collection. Then I started using lambskin suede in colors: emerald green studs on teal leather and teal studs on hunter green leather. The leather was sprayed with enamels and graded. I did gradations where the studs started at the shoulder in dark purple and as they moved down the arm got lighter and lighter. We were doing all these things with colors that nobody had ever done.

And just as I began to experiment with gradations of spectral stripes, the economy got weird and I had a Kaposi's sarcoma lesion emerge on the corner of my mouth.

A schmuck gets what a schmuck deserves, which is not a beautiful home in the forest to create beauty in. A schmuck gets to pour drinks on Christopher Street and to say, "I'm an alcoholic and HIV-positive." During the saddest era, that was my story. For some reason I wasn't accepting my creativity. The

night that I sent off the first jacket that I made to my friend Eric as an amend, I walked into the bar where I was working and gave notice. I knew that one of the things I needed as a part of being HIV-positive was my art.

MICHAEL KEARNS
(actor)

When AIDS happened around '82–'83, it focused me and opened me up to the idea that I could write and direct. It sounds like such a soundbite to say, "AIDS made me an artist," but it's true. Even today where it's at its absolute peak for me in terms of my own griefs and fears, [making] the art is the only time I can really be in the present. When I'm rehearsing that show, I'm not grieving. Or I may be grieving, but it's in a focused package.

PAUL MONETTE
(author)

I tested in the spring of 1985, but the more important date for me was March 12, 1985, the day my lover, Roger, was diagnosed. That was the day my world changed. For four or five years, I had been working with less and less enthusiasm in the vineyards of Hollywood and once Roger got sick I couldn't do it anymore. I just fell apart. I had not really worked on my own work much. I was fussing with a novel and people kept saying, "Why don't you go back to it, it's such an interesting idea," but I could care less. I spent a period of about six months paralyzed emotionally and intellectually and living with a fear that was like looking into the headlights of an oncoming truck. I was not able to find a way to put it in writing. I really thought my writing was over.

During the summer of '85 my friend Carol Muske, who's a poet, and I agreed to write some letters back and forth to each other in the form of poems. I had to keep Roger's diagnosis secret for the first six months; I hadn't been able to talk about it at all. I began to write those poems, maybe one every ten days during the summer and less often during the next year, and both Carol and I got some very, very powerful work out of it. Mine was more and more about AIDS even if it was something I couldn't name.

For three or four years, my immune system stayed up, even through the writing of most of *Becoming a Man.* I was only diagnosed about seven months ago. Now I'm in a real crisis about what to write or if to write or how to write. I haven't felt that in years. I wrote five books in five years, almost seamlessly.

EDMUND WHITE
(novelist)

As soon as the test was available in Europe, in 1985, I went to Zurich and had it. But, in those days, it had to be sent off to America, so I had to wait two months and then go back to Zurich to get the results. At the time I was involved in a relationship. I was going out with a Swiss man who I was sure would be negative and I would be positive. He was the one who wanted us to have the test. And I said, "I'm a good enough novelist to be able to figure out what will happen: you'll be negative and I'll be positive and you'll be a good sport about it and a year later the relationship will be over." And that's exactly what happened. Although you could say I might have pushed it that way because I so expected it to happen. I describe all this in a short story called "Palace Days," which I wrote not too long after.

✧

I wrote three stories for a book of stories about AIDS called
The Darker Proof. I wrote three, and five are written by Adam
Morris-Jones, an English writer. It was his idea. At that point
there was very little fiction about AIDS and he was getting fed
up with seeing experts—that is, medical doctors and biolo-
gists—on television talking about it or writing about it in the
newspaper. The risk groups or the people who actually had the
disease were almost never heard from. There was a lack of the
human and subjective side of the disease being reported at that
point.

I'd really like to write a big novel, probably similar in form to
David Feinberg's *Eighty-sixed.* That's probably been the most
successful of all the AIDS novels. By the way, people hate AIDS
literature, people don't read it. In fact the head of the gay book-
store in London told me that the only title that has sold in
England has been *Eighty-sixed,* partly because it was amusing.
The idea there was to show before and after the crisis, the same
people. So the sections before, like ten years before, are quite
funny and very full of all the characteristic verve and excitement
of gay life of that period, mid-seventies, Fire Island, middle-class
white gay life, which was very creative and fun and luxurious
and stylish and triumphant. His book is formally very complex;
he switches back and forth. I would like to start at the beginning
and go to the end in the most simple chronological way. A very
personal story. Just start in the seventies with my own life and
what it was like—going to Fire Island and raising my nephew
and living kind of hand to mouth, but in a fun way, as a free-
lance writer and having zillions of affairs with everybody. In the
first person. My other novels are in the first person, too, *A Boy's
Own Story, The Beautiful Room.* This will be the final part of that.
Will I call the main character Edmund? I don't know. I've never

done that, but maybe I will in this one. Part of my idea is that as this trilogy goes along it becomes more realistic, so maybe I would use my name. But if you say "I," you don't have to actually name yourself.

The thing about fiction is that it's so speculative, you don't really know if it's any good or of any importance or value to anybody, whereas I do feel that the biography is important. [White is presently writing a book on Jean Genet.] I mean I feel that I won't write another one. And I do want to do my own work now, but it does seem to me that there's something solid about a piece of research that's somehow incontestable and irreproachable in a way that isn't true of fiction.

TORY DENT
(poet)

I'm in the process of writing a novel. It will be written in the first person. There are biographical parallels; it's about a woman's journey in finding herself. There's an illness, I didn't make it HIV, I didn't want it to be. I'm not really sure how it's going to change, and maybe someday I will write about what I have experienced. I suppose I just feel like I'm coping right now.

It became imperative to write as a health practice. So it's more like, you don't brush your teeth just once a week. Good writing really comes out of practice; if you rely on inspiration, after a while, you're hard up. Inspiration comes from practice. It's like an athlete, or a musician. You have to practice every day, you have to do the scales in order to get the moments of inspiration where you improvise. I see it, too, as necessary to my body. I just

feel differently about my body, in my body, when I write. It's like working out, almost. That became clear as a bell to me. So I probably write more, like I need to exercise more.

Plus I'm less circumspect about what I write, I'm more apt to trust the ideas that come while I'm writing rather than expecting them to come beforehand. Whether or not it's a good poem, I don't care anymore. I just write and chances are I often like it okay. It's like fishing every morning. I like just going out there and fishing, it gives me peace of mind.

Many of the feelings that testing positive brings up I had felt already. Feelings like there was something wrong with me, some reason why I wasn't able to be loved, that I didn't fit in. All those feelings which testing positive made concrete, yet illusory, because who knows what an antibody really means. If anything it just pushed me further to levels of emotionality and made writing all the more important to me. What changed is I had to write and I lost the need to write one consolidated poem after another. I didn't care if I wrote the same poem again and again and again. I just needed to write. I became much more trusting of my own instincts. After "Jade," which appears to be a five-page poem about testing positive, what more could I say about testing positive? But you know, I don't care, I will write it as long as I need to write it. Maybe before that I felt that each poem had to be self-contained, should be different from the next and original as it could be. And now I see that writing is just one long process.

"Jade" was the first poem about testing positive that I read in public. It was a decision I made to come out of the closet about being positive. I read that poem in Cambridge and it was such a strong experience, reading it in public and exposing myself to strangers, that it moved me to write a second poem, "A Poem for

a Poem," which was about reading "Jade" in public.

"A Poem for a Poem" is [also] about the actual writing of "Jade," which is such a strong, long poem. Really, that poem got me through the first winter of being positive. What changed about my writing was my feeling about writing. The bifurcated path between the desire to write and the desire to be recognized grew wider than ever, and it became imperative to my healing process to write. Writing that poem "Jade" really took me, carried me, through that winter, like the image of the rope bridge in "A Poem for a Poem." I thought it was cathartic, that I was able to exorcise it from me, but in fact I realize that it has become more of me. The double meaning of testing positive and then writing about testing positive is that you can never seem to get it out of your system. Sometimes I wonder if I live to write or if I live according to what I write.

ESSEX HEMPHILL
(poet)

I knew when I was working on *Brother to Brother* [*New Writings by Black Gay Men*] that I was going to be dealing with material that was addressing AIDS and HIV infection. I felt that I would need to be real honest with the material's impact on me and thus, by extension, very honest myself. A combination of forces was driving me to make the decision to go in and test. Some of the material that came in was so moving that I felt I had a responsibility to know about myself in terms of my carrying the voices of the men who were submitting work for the anthology specifically around AIDS.

Walter Rico Burrell's *Scarlet Letter Revisited* was probably one of the primary pieces impacting on me and stirring me on: the real nakedness of it, the way that it's set up as a diary, and how

revealing he is of himself. Walter Rico Burrell, Marlon's [Riggs] revelations in *Tongues Untied,* those things which cited significant cultural things, along with my day-to-day experiences, exerted a pressure to know.

I put all the material relating to AIDS in one section [of the *Brother to Brother* anthology]. In order for me to work with it, I had to be open to it, to ponder it, I had to put myself in the place of the reader who would ultimately pick up the book. I had to know if the work had resonance; if it was moving me, then the potential for it to move others was there.

I don't think I had a fear of testing. I just didn't want to know at that point in time. Mine was resistance with a lot of clear understanding of what was going on around me. Mine was a question of, did I want one more burden to contend with? That's where I was coming from. It's been a contentious psychological process for me around the issue of AIDS. Contentious in the sense that there is my clearheadedness and understanding what is at risk here, the issues, and yet at the same time there was a moment where I didn't want to contend with that. There was a contention I was waging within myself. The pressure of the project was resolving that in many ways. I had to be open to the material, and part of that openness meant that in some way or the other ultimately I would respond to it.

After I found out I was positive, I was not public with it for a while. That moment began with a reading I did in California with Marlon and Alan Miller, at the *Brother to Brother* signing in San Francisco. In my personal space there was one movement—one act of speaking, if you will—and in my public space that was yet to manifest itself. The poems I have written about AIDS probably number three or four, which I think is reflective of the scenario that I'd set up. Clearheadedly I knew what was going on, but in another sense I just didn't want the burden of it at that point. That, of course, would change.

LARRY KRAMER
(author)

Some of the novel is written in the first person, some of it isn't. It's not a traditional novel. It's an epic novel. It has an enormous cast of characters. I feel it's almost an obligation for me to write it, and this probably makes it different from anyone else just sitting down to write a novel. I have been involved in this fight since day one and I've seen it all and I know everybody and I know where all the bodies are buried—figuratively, symbolically, and literally. I feel truly that it's incumbent on me to write it and maybe in fact that's why I've been spared: so that I might still be able to write it. I don't know why I'm still alive, because all my friends are dead. But I am, so I feel even more obligated to honor their memories. I think that's what I try to tell myself when I pull myself away from ACT UP [AIDS Coalition to Unleash Power] and try not to feel guilty, because they need me, too.

You asked if anything had changed. Well, I think I'm much more secure in what I can do now. I haven't got time for "Is it good enough?" or "What are they going to think?" or that kind of stuff, which comes so often when you're a struggling artist. There. I used the word. A struggling writer. I try not to use the word "artist" because it's scary. I'm just going to do the best I can. I feel that my language is much stronger and that my years of writing political stuff have given it a fiber and I'm pleased with what I've written. It doesn't make any difference. I'm going to be dead by the time my book comes out. Virginia Woolf has an expression about what a novel should be—you must find an envelope that is fashioned so that you can put everything into it that you want to. And that's what I think I have finally found. I have been working on this novel for the last ten years. It is not

just something I'm starting on. I already have close to a thousand pages and the hard thing was finding a structure that would be that envelope. That would make people read on and that would allow me to say whatever I wanted to say. The structural things don't come out of anything more than trial and error. They came out of struggling with it for ten years and working and reworking and looking and rearranging and rethinking.

STEVE BROWN
(filmmaker)

One of the first music videos I did was for a band called Mudhoney. I did it just before I got tested. Ironically, the name of the song was "Here Comes Sickness." The whole song is about sickness personified as a sexy, seductive woman moving onto your street. In it there are these explosions, and words taken from this educational film related to illness. It was a big deal to put the word "virus" in, because to me it was obviously AIDS. I mean, to put "virus" in meant AIDS. I thought, Am I putting it in because I'm thinking about AIDS? Is this a good idea? But I just did it. It was like making fun of something that's not really funny.

It was odd to me how I came to do this video of a song that was about sickness walking in right as I was about to find out whether I had this thing. It gave me the opportunity to turn it into something lighter. I don't know. I tend to be a joker when it comes to this kind of stuff anyway. Here I had "virus, virus" in front of me and I was thinking about AIDS the whole time that I was doing it.

I don't think I've had a huge opportunity to put AIDS into my work. I mean it's hard to have it pop into MTV-oriented stuff. I

am putting together a compilation for the company, and in the credits I'm going to put "Don't fuck without condoms." But that's about it. I thought of making a documentary when I went down to be in this drug trial. I actually snuck in my 16-mm camera and shot the guy in my room all hooked up. Then I said, wait. Pull back, live your life. You don't have to turn your life into a movie. I've had some other ideas about a movie with somebody dying of AIDS in it, like *The Bitter Tears of Petra Von Kant*. It would be in a hospital room, everything happening in that same room and all these different people coming in and out.

ARNIE ZANE
(choreographer)

Prejudice was going to be a solo for Janet Lilly, and I still regard it as a solo. I was not well. I was in bed here, and she was on the floor there and I would get up and I would try to do some steps and she would instantly have to play them back to me and I'd keep what I kept. The dance is all built on a diagonal or a circle. . . . Then I was throwing out words to her like "malign," "prejudice," "rage," and she'd have to do something physical in her body. Now this was in these late stages. . . . For years what I loved to do was get up, put music on . . . and improvise extensively to it on video. Then, take a dancer—I have trained some dancers who have great what I call "video minds"—to learn the material off the television and play it back for me. Then I edit it. Then I have them teach the material to the company at large. Then I really start the piecing together.

After Zane had died, Bill T. Jones spoke to me about his partner in life and in art: "When he was getting more and more ill, he really wanted his own choreographic signature. He was growing strongly as a person and he

wanted his own identity. He wanted to pull away from the collaboration, and just as he was doing that, he began to lose energy. Then for him to give me his last works—it was very difficult for him to say, 'Well, just go ahead and finish them.' There's this polishing and an intensity an artist has to focus on a work to give it its final breath of life, and he wasn't able to do that.

"And on one level, it's almost artificial to talk about him alone because he and I did so much work together. I know how we worked, how we shared ideas, how one idea would grow out of another."

Slowly, over the past year and a half, the past year and a half for Bill and me, we've begun to change our thought and our reasoning, and are trying to go back a little bit to our roots and see what it is that made Bill and Arnie, Bill and Arnie, and trying to bring that to dance.

CYRIL COLLARD
(novelist/filmmaker)

In his latest novel, *Les Nuits Fauves,* the protagonist, after testing HIV-positive, has unprotected sex with his teenage girlfriend. Collard told viewers on French television that the incident was autobiographical.

From the moment that I slept with her, there was a desire to tell about this experience. It's a process that I had to take responsibility for, and it started by writing the book in the first person. Then when the book came out and journalists asked me if it was an autobiography, if I really did that, I said yes. And it ended with me on television where the journalist practically treated me like a murderer. Now I'm making a film of the book.

For me the artist has a social function as a witness. I wanted to describe this HIV-positive person, my main character, as someone who is caught in a network of contradictions and ambiguities. Someone so complex that, at a certain point, he is

able to do something as horrendous as fucking this girl without telling her he's positive.

HIV deepened my rapport with the truth. I'm someone who doesn't lie. The only time I ever lied was when I made love to this girl without telling her that I was positive, which was something incredible. For me, it's the only despicable thing I've done in my life. It unveils how very, very unclear the rapport to being positive is. At that time, it was something I hadn't yet assimilated inside myself.

In the first book [*Condamné Amour*], the question of love doesn't really come up. There are people who are tearing themselves up, but that's not the story. In the second book [*Les Nuits Fauves*], the autobiographical and linear one, there's love, but it's a search for love. It's there somewhere, but it doesn't really appear. And the third book, the journal which covers 1990, will be a love story. So there's a curious evolutionary rapport between the extreme simplicity of style, the retranscription of reality, and the representation of love. I'm sure the virus has something to do with this manner of representing things.

At the beginning of *Les Nuits Fauves,* my last novel, the protagonist doesn't know how to love, and by the end he realizes this. Throughout the story he's evolving toward that. I don't know if he's capable of loving, but at least he's able to recognize that he doesn't know how. That's already an important step. Before, he was in this narcissistic blockage where he didn't even know he was incapable. At the end of the book he admits it. Of course, throughout the whole book there was the menace of the illness. In the first book, the protagonist doesn't even ask himself those questions.

And in the screenplay of *Les Nuits Fauves,* I want him to develop earlier in the story. I want a happier ending. Not a

commercial happy ending in order to have more of an audience, just something that corresponds more to my own personal evolution. I want the character's conscience to be stronger. I want him to look at himself more critically. I want him to realize earlier that he doesn't know how to love. That doesn't mean that he becomes able to love, but I want his attitude toward the female character to evolve earlier than in the book. I want the sensation of a greater transformation in the character.

Speak about the rapport between your art and reality now.

The artistic movement is one of leaving reality. For me the artistic act is not about creating an imaginary world. It's a way of starting in reality and leaving, finding in this reality something that exceeds itself, but not by creating something that's parallel to it. It's trying to find that concentration of emotion, of an essence. It's truth, it's reality, and at the same time if you can go further than that, you can represent something that is just a little bit more. Stronger, more beautiful. Truth in itself is not interesting. What's interesting is the juice, to concentrate and produce something that makes us want to live, to produce emotions, ecstasy.

When I think back on it now, I see that AIDS was almost a premonition, a prophesy. I woke up one morning, and although in twenty years I had never been sick, I woke up and I collapsed. I had stomachaches, headaches, fever, I couldn't stand up. And they never found anything wrong with me.

It was the beginning of a period, which lasted several years, of this hypochondriacal condition of imaginary illnesses. And, like the character in *Condamné Amour,* I was absolutely obsessed with skin cancer. I'd have these anxiety attacks, where I'd get up in the middle of the night and I'd anguish over a beauty mark. It's very strange because the first manifestation of AIDS

that I got was Kaposi's. Curious. All that to say there's a link between the unconscious and the things that actually happen. Strangely, as the years progressed and I found out that I did have the virus, the anguish diminished. I was much more anguished during the period where I was inventing illnesses. Knowing that I had the illness, that it was real and tangible, there was no longer any fantasizing about it. In a certain way the fantasy went elsewhere.

Am I harder on myself now? I was never very complacent. I'm a bit spoiled and capricious, but I've never been artistically complacent. I don't think I've done the eighth wonder of the world every time I write a book. And when I see my films again there are a lot of things that don't please me. But now I'm harder to please.

KEITH HARING
(painter)

See, when I paint, it is an experience that, at its best, is transcending reality. When it is working, you completely go into another place, you're tapping into things that are totally universal, of the total consciousness, completely beyond your ego and your own self. That's what it's all about.

PHILIP JUSTIN SMITH
(playwright/performer)

I met him at a reading of his play. He was hurrying out of the theater to get back to the hospital before the nurses changed shifts and noticed he was gone. The next day, I went to see him in the hospital; he was recuperating

from his first bout with *Pneumocystis carinii* pneumonia (PCP).

I write every day, in the mornings. I feel clear then, and in my sleep state I go through things and write them down. I usually try to do some subconscious writing, things that are up for me personally. And out of that something else will come, like a poem or a short piece, and sometimes the play.

Writing heals the experience.

My dream around dance right now is to get a grant and do a workshop around HIV, ARC, and AIDS and use a system of rhythms and isolations to acquaint people with their bodies—to help them discover their responsiveness to rhythm and music. Get a three-piece percussion drum combo and a class of about twenty and do line work with repetitive motions, work that integrates you into your body with the music and rhythms. Create a dialogue for these people with their bodies in a conscious way, and from that experience to dance. Dance the symbols, dance the story. Not say, "Oh, this is what dance is so we're going to impose that on this." But to help them into their bodies and then together to discover how their dance would look. I have never met anyone who didn't want to be a dancer. It's our birthright as bodies. And every body has its voice. Everyday I put on my African music and I go through my body and I dance the rage and I dance the bliss and the stillness.

I'm writing like Anaïs Nin now. I'm channeling a French woman. [*Laughs.*] People are saying to me, "Your feminine energy is so beautiful now." Normally in life I feel very male but I notice that my writing has been very "diary of an Edwardian lady." The stuff sounds like myth.

❖

Art is reality brewed down to the finest ingredients and put back together without the superficialities.

HERVÉ GUIBERT
(novelist)

I've disappeared and reappeared as a character in my books. I'm the protagonist, but it could really be a series like *Hervé Guibert in Morocco, Hervé Guibert and His Great-Aunts, Hervé Guibert Has AIDS.* It's true that I've created myself as a character. But I don't think I know him like the readers know him. The creation has happened somewhere between me and the book. It's strange because in life, I'm very chaste, and at times in my work very shameless.

BO HUSTON
(novelist)

When I went to San Francisco to interview him, he had just returned from Switzerland, where he'd undergone an experimental AIDS treatment.

When I was really sick, the writing kept me going. I had a lot of work to do for the newspaper. I really stopped doing the newspaper column over the last eight or nine months. I couldn't meet deadlines. If I had to start making priorities, it would be trying to get my own fiction going. I never had blankness. I have more blankness now, actually, because after this treatment I have so much energy, I just want to go run around and do things.

The second novel is about a guy with AIDS, but it took me a while to get to that. I knew I wanted him sick but I wasn't sure

I wanted to say AIDS. I also wanted to try to follow my own experience, which was the limbo of AIDS. I was interested in that. That there's this population of people who aren't the familiar media figures of the skinny guy in the bed who can't move, but who have AIDS hanging over their heads. So whatever you want to call them—positive, ARC—that's what I related to at that time. I was really under the threat of AIDS, but I had no real sense of it either. I was walking around feeling okay but thinking I had three years to live. It made the world a very nonsensical place. I gave that to this character.

That book is called *Remember Me*. It's about a writer trying to get published, the sense of urgency he has. It's written in the first person. It's really about his friendship with a woman named Charlotte, about their relationship. Part of who he is, is a gay guy with AIDS. They're very isolated, they live in a small town, she never leaves the house. So it's a rich story, it's not just about someone with AIDS. It's about having to readjust your understanding of life to cope with the arbitrariness.

I think of writing as what to do with material that already exists. It's not like I'm creating something. I'm not trying to romanticize the process; I also think people have skills. I consciously try to construct something, but basically the urge or impulse to write is a compulsion. I don't mean an obsessive kind of thing, it's just how I respond to the world. I think of it as how I cope and how I make sense of the world. Writing *Remember Me* is how I got through conflicts in my relationship. And writing *The Dream Life* was how I responded to whatever was going on then.

The new work is called *The Listener*. I always write about these small towns. The crazy lady whom everyone doesn't like has a seven-year-old boy that she uses to fulfill her own needs.

He starts to get ill with an unspecified illness. She takes him to a doctor who has no explanation and can't help him. She takes him to a faith healer and the faith healer can't help him. And then this other woman appears out of nowhere, so it shifts from this logical story to a magical thing. This woman has a method for healing that doesn't make sense, but the mother tells the kid to do it and the kid is totally healed.

PETER ADAIR
(filmmaker)

At the facility where he got tested in San Francisco, like everyone else he had to watch an educational video explaining HIV infection. Ironically, he had made the film. He later went on to make *Absolutely Positive*, a documentary about a group of individuals who have tested HIV-positive.

We always felt I'd be a part of the film. We always felt it would be useful for me to be in it for no other reason than that it would give the film a sense of authority and intimacy that it wouldn't have if it were an outsider looking in. Some of the [film's interview] questions implied that the filmmaker was HIV-positive, and so we felt it was important that I clear that up to the audience. But we weren't sure exactly how. The form of *Absolutely Positive* is very much like the form of *Word Is Out*—a series of intercut stories told as a composite. I think the form is very powerful and it's a form you see everywhere now, it's ubiquitous. I think *Word Is Out* is pretty much the first example of it.

I wasn't that interested in making *Absolutely Positive*. It was a subject matter I put off for a long time. I didn't want to think about it all that much after I tested positive, which was pretty early on, not long after the test became available.

JAMIE MCHUGH
(dancer)

You teach what you need to learn and what you learn is what you teach. And that's why I'm here in this lifetime working with the body, listening to my own body and trying to get people back into their own bodies and to experience themselves. The illness is just something else. It's the proof of my work. I believe we all can empower ourselves, that we can have much more dialogue and communication with our bodies. Arnie Mindell, the guy from process-oriented psychology, said our bodies dream up what we need to hear. I like that image. It's just another way of speaking to us with no judgment attached.

I consider myself an artist, but I haven't really performed in the last four years. I'm trying to look at performance from another point of view. I'm much more interested in participatory ritual, people doing things together. I'm not really interested in being the star. I'm also starting to feel like I have more to say than I used to and I feel like I want some kind of form for that. I'm not really sure what that form is, so I'm searching for a form.

My art right now is guiding others on their journeys, being in contact, working with my hands. For now my facilitation work is my art, yet I also know there's a place for me as an artist that also needs a voice. I don't know what I'll do, but I feel like my challenge is to collaborate with other people and yet not lose my own voice in that collaboration process. Something where people, witnesses, are involved. Where there is a sense of ceremony, but ceremony that's not oppressive. I don't know what that next place is, but it's important for me not to put it on hold. I know there's a part of me that needs it, that desires it and that needs to make time for it.

REZA ABDOH
(playwright/director)

I mentioned that the audience seemed unsure how to respond to his play, *Bogeyman,* an indictment of our society's inability to deal with sexuality, illness, and death.

> The genuine audience response is a response where people have in some way managed to de-detach themselves from the experience. I wouldn't say to attach, that's too much to hope for. The audience comes in ready to detach. Especially in theater, because the event is first of all physically removed from them, and psychically it's happening on a plane that is beyond their immediate reach. It's subliminal. So when the experience forces them, or invites them, to de-detach themselves from what they are witnessing, then I think the relationship of the viewer to the event is a genuine relationship. And they can interpret it, they can read it in certain different ways. They can emotionally respond to it. They can become a part of it. They can hate it. They can think it's crap, whatever. But it's impossible for them to be in a state of stasis. So it's movement that I'm after. An infusion of a radical or a subtle shift in their perception.

I told him *Bogeyman* made me think of what David Wojnarowicz had said about building rather than destroying.

> In a time of chaos, and in a time when one's body is subject to deterioration, I think it's a natural impulse to want to create and build rather than to continue to destroy. Of course though, for that to happen, you also have to destroy. I believe that. I don't believe you can put shit on top of shit.

RICK DARNELL
(choreographer/performance artist)

I want to do *Passions: Things You Do to Keep Yourself Going.* Those everyday things. *Passions* has three sections. The first is called *There Are Good Things Going,* about picking back up out of this epidemic: "Hey, we're in it ten years, we've all lost people, we're all fucked up, we all know the deal, we all know the information, so let's get things rolling." In the piece there are all these tires that come rolling across the stage and we do things with the tires, just a little acrobatic tool. The second section is called *Clearing the Fields,* and there are all these rocks upstage and we do things with the rocks and in the end we make graves with the rocks, some have names on them. The last section of the piece is called *How Do We Get There from Here?* and it's a metaphor for "Okay, we've got things rolling, people are dead, we've taken care of the dead, now what?" And we build this staircase out of wood—it doesn't go anywhere—and we go to the top of the staircase and look out at the audience and that's how the piece ends. Once again it's a challenge: "We've got community, we've got the power, what are we going to do with it? Where is it leading us?" I want to ask the audience questions. It's so easy. I'm not a great dancer, but I can pull this off. "What can you do?"

ANGER, PAIN,
AND FEAR

We are a feelingless people. If we would really feel, the pain would be so great that we would stop all the suffering.

—*Julian Beck*
(writer/director)

How does anger influence the creative process of an artist living with AIDS? Can his art help him deal with emotions usually avoided? By putting anger outside himself and into his work, can the artist avoid depression and misdirection of his rage?

In what ways does the anger come through in technique? Can anger generate additional vehemence and force in the expression of an idea?

How does pain shape the artistic process? Does working lessen the pain or does the act of creating itself become more painful? Does pain push the artist into new areas of perception and understanding? Does it alter his perspective?

Choreographer/dancer Anna Halprin, who uses movement as a healing agent in her work with people who are HIV-positive or who have AIDS, stated that "when a person experiences a physical crisis, it seems very natural to return to the body, to return to the source. The body has all the wisdom of the ages. If we can find some way to tap into this wisdom, the potential for healing is beyond anything any of us can even imagine."

If the body is the source, would pain give added imperative to physical gesture or movement?

And what about fear? Does fear influence the artist's formal choices? Does it add intensity to the art? Does unresolved fear come out subtextually or symbolically?

Testing HIV-positive can bring a gamut of previously unexperienced fears. Does the fact that an artist already has experience confronting the mysteries of the creative process make him any less fearful in the uncharted emotional territory associated with AIDS?

Working through fear in one's art can catapult the artist into a more assured space in his life. Creating can be cathartic. Art gives form to ideas and to feelings. It is a process of putting the deepest personal questions and emotions outside the self. When that happens, the burden sometimes becomes lighter.

When the fears are put outside, does the work become more vital, more alive? Does the artist?

"Dealing with the unknown—with AIDS, you go through it again and again, you're never over it," said Irene Borger. "But when the fear starts to come up, and the next level to deal with comes up, you have some kind of experience of trusting. You almost have to surrender and fall through like Alice, just let yourself fall. In the workshop, what I try and do is set up a situation over and over again so that people have the experience of trusting the unknown. Because it seems to me that with AIDS the constant unknown is the only constant."

Fear of the unknown. Is it fear of death? Of immobilizing illness? Of not being able to do all the work? Does the artist transcend this fear in order to

work, or does he work in spite of it? Because of it? Can art be an arena for exorcising otherwise destructive emotions?

Is art prolonging lives?

MARLON RIGGS
(filmmaker)

Making the documentary *Tongues Untied* was a means for me to almost therapeutically resist a paralytic fear of confronting death. I saw how other friends of mine had been utterly paralyzed and retreated into that internalized and desperate space where you don't even talk anymore with friends and family, where they seemed to utterly hate their bodies. *Tongues Untied* became my Bible, particularly when I hit those critical moments of need for active, constant engagement with the world.

Tongues Untied also became a way of wresting control of those demons of racism and homophobia, and internalized racism and internalized homophobia, because it's not simply out there, but deep inside, where so much damage is done. It was a way of wresting control of all the rage and not allowing that rage to consume me. I see so many black men, gay or straight, positive or not, who are consumed by their rage, and who act out in all kinds of ways: sexually, either heterosexually or homosexually; physically, by brutalizing women or other men or themselves. Their rage has become a source of profound irritation and their only way of dealing is to unleash. I wanted to unleash but in a way that would be healing. To use the rage, rather than to be used by it. *Tongues Untied,* as well as *Anthem, Affirmations, No Regrets,* all these works are ways for me to constantly assert control over this virus and all the discordant,

chaotic emotions that it would engender if I simply allowed myself to believe I were a passive victim.

TORY DENT
(poet)

What testing positive has really changed for me is that it's provided so many opportunities for exploring feelings I probably never would have felt before. Dying of AIDS. Dying alone. Dying alone of AIDS. Every nightmarish feeling I could anticipate has come to mind, has kept me up nights. I think the most profound lesson in testing positive was realizing that it's not the events in life we're afraid of, it's the feelings.

That summer of 1988 I met a man and we fell in love, very seriously. I didn't sleep with him because I wanted him to know about the test first. But it was this really tormenting, painful process of trying to figure out when to tell someone. When I told him, he had this really mind-blowing response. He wanted to wear surgical gloves to touch me. He was terrified. He was terrified of my body. That was probably the most painful part of it. I felt like maybe I could have an inkling of what it felt like for blacks to be segregated. For someone to be afraid to even touch you. That's what motivated me to write "Jade."

I find that, like guide flags on giant slalom trails, my poems help guide me through my life and are my momentum to get from point A to point B. I really can't imagine how I would have been able to cope with testing positive without my writing. Truly, as Margaret Bourke-White said of the camera, it was my best friend.

DAVID WOJNAROWICZ
(painter)

I get angry at things I witness, I get emotional about certain things I've witnessed or perceived out in the environment. I get touched in a way where I want to get involved, or to put things into forms or images or words. I feel like I wrote a lot of it out last summer.

I went through a pretty bad depression that I wasn't aware I was even slipping into. Part of it's becoming immobile, or not having great mobility in terms of weakness and stuff. For me that's the worst thing that can happen to me. In my structure of fears, it's what I can least handle. I just hate feeling like I'm stuck somewhere.

There have been statements made in the press that seem to use the fact that I have AIDS as an excuse for the tone of my writings—for my anger at these individuals. This is insulting to me. Anybody has the right to be outraged and the right to express these things. I was writing about these issues in this "tone" well before my diagnosis with AIDS.

Not creating gave me some anxiety. I thought, How do I live? How do I support myself? How do I eat? How do I pay the rent? Recently I just stopped fearing that. To feel emptiness, a blankness, is an interesting state of mind to me. I mean, for a while it didn't occur to me that it was interesting; I was anxious about it. I don't think I've fully accepted that I might never do any work again, but I've tried to accept the fact that this is how I feel at the moment so that I can give room to whatever I'm going through or experiencing. If it gets replaced by another state, then great, and if not, it's not really a terrible place.

LARRY KRAMER
(author)

I have a book of essays called *Reports from the Holocaust,* which is all my collected writings over the years. And they're very high-pitched, many of them, and very angry. And I'm not that angry anymore. Or maybe everybody else is, too, so I don't sound so angry. I'm more resigned, I think. I don't have hope that this is going to be ended. I don't have hope that I'm going to be saved. I don't have hope that any of us are going to be saved. I can no longer maintain the fiction that we're going to save our own lives, that activism and anger are going to save our lives.

Jerome Robbins came up to me at a memorial service and he was all in tears about how he had just been to the hospital to visit a friend and how awful it was and would it ever end and what could he do? And I looked him right in the eye and said, "Why don't you put all that into a ballet?" He looked at me like I was crazy and he walked away from me without even saying anything. And that makes me so angry. Tommy Tune gives these pompous interviews about how he wants to bring joy and happiness to the masses, and it just seems to be such a waste of a great talent because he is such a wonderful director. How you forge art out of all this I don't know, which is why I get frightened of the word "art." I'm just writing ten years of what's happened to me, which is turning out to be fifty years of what's happened to me because it just goes back and back in time.

ARNIE ZANE
(choreographer)

About a year ago I had to have some surgery, and I thought, Oh no, you don't really have much time left. You have to make your last dance. I thought it was going to be the last dance that I was making, and I went into the studio and I was very angry. Very angry. I *am* very angry. I'm horribly angry. Because I could make dances for another forty years. And my real dream was, at one point, I wanted to bring our work to Broadway.

I was making this dance *The Gift/No God Logic.* I didn't want to make a dance about AIDS. I did not know how to begin to make a dance about AIDS. . . . I went into the studio. I had no idea prior to building it what I would do. And one of my dancers was late. And I was getting angrier and angrier, because I have those days when I'm well and I can work and then other days when you can't do a thing. So this was a day I could do something and my dancer, Demian, was late. So I took a piece of paper and on it I made five little designs and the four dancers have to keep coming back to it . . . a very narrow, almost minimalist conceptual idea.

I feel cheated by the world I live in. I feel I've been done wrong. It's like James Baldwin was saying before he died: In America I was born into this country, considered a nigger, and despised for being one. This was a man who died with a great deal of rage. And I feel a great deal of rage in my life now. But you know something? I was speaking to Bill [T. Jones], and even before I was sick, I have to point out, I was a very angry person. I was angry well before I was sick. I'm only angrier.

I thought that dancing and being hurt went hand in hand. I really did.

YURII CACHERO
(dancer)

I feel it's important for me to not always be obsessed with the meanness of having AIDS. But to put that energy out to the community. And that's why I'm involved in the Wedge Program, speaking to high school kids and hopefully enlightening them by telling my story. Enlightening them to be very careful, to be wise in their choices and in their behavior.

PETER ADAIR
(filmmaker)

I'm not a particularly angry person. For me—again, therapists argue with this—to get angry there has to be something to get angry at. Getting angry at a bug doesn't make any sense to me. But I think I'm in some kind of denial. Other people's anger threatens me. Not anger like ACT UP anger, but the unfocused anger that people get when they find out the news. It scares me. So I'm sure there's something going on with me. To this day I don't feel any anger. I think we're lucky to be here. I think we're lucky to be here for as long as we get to be here.

There's a little degree of anger in the character I'm writing now, but I don't think the voice in *Absolutely Positive* is angry at all. If I am angry, it's always couched. It's provocative but, like sarcasm, you can deny this snottiness. The character in the feature, he's like me. He likes to think he's in control and he likes to think that his exit is going to be elegant or at least controlled. And to a large degree it is. But there's one thing that he can't control, and that's the reaction of his friends. He denies what his

departure is going to mean to his friends. It's too painful. He can cut his own feelings off and say, like I do, "I'm going to go, I've had a good time here, I'm not angry, I've been lucky to have what I've had in life"—but he can't deny other people's feelings. He does his best. He kicks someone out of his hospital room for being weepy. Over the course of the film, this feeling of loss that his friends have begins to affect him, and he realizes that he hasn't done it all. So in that way, I wouldn't say it's anger, but it's fear. I'm a little afraid of pain and disease, but it's the loss of control that probably scares me more than anything.

STEVE BROWN
(filmmaker)

The rest-stop story that I wrote is all about love, this one guy's idea of love. And I guess the guy is me. I think love is pretty painful. I haven't had a huge amount of inspiration to make things about love. No, I think more about making things about anger. Indictments.

ROBERT FARBER
(painter)

I got my diagnosis in October and it took me until January to finish the work I was doing and come to a place where I felt, well, what's the point? Utter existential despair. I just felt like it doesn't matter if I start on my right foot or my left foot, whether I paint or I don't paint, I have this thing in my body and it will do what it will and nothing will make any difference. I can't say that I stopped dead painting, but I didn't see the point. And I just slid into despair. It was also a period where the terror hit me.

I think I had to slip into this total cynical existential pit to start finding a reason to continue. I remember saying, "What does it matter if I paint or not? There's an absolute that's not going to change." I was very, very angry.

ACT UP has really helped me in my work. It's about anger that's channeled into doing something about the AIDS crisis. And it suggested to me that I could do something as an artist. This is really the first work that I have done that's related to a current situation. Joining ACT UP was devictimizing and allowed me to channel my anger into positive action. And that bled over into my studio. I felt like I wanted to do something creatively about this crisis. I wanted to say what I could about it.

This work, which is all about AIDS, is right in my face every day I'm in the studio. I've never been frightened of my situation when I'm working. While I'm working, I feel safe. I've always had a hard time leaving my studio at the end of the day. Painting about AIDS is comforting or familiar or interesting, or fun even. Painting about AIDS and the Black Death is a way I have to face my fear. It's an antidote to fear.

KENNY O'BRIEN
(designer)

After my first two or three weeks of like, "Where's the miracle?," I accepted it fully. It was fine. I was fine with AIDS. And people would say, "Aren't you angry?" And I'd say no. This is part of my story in the world. Why would I be angry? Everybody gets theirs and I'm going to die of AIDS. So I'm going to show up for the process and see. And since then I've used it in my work.

✧

My creative thing and the spiritual thing and recovery are all braided through a lot of painful processes. Once the enormous pain about my family and what they thought of me—once that was over, I let go of the pain. Then I was able to design this house and the land, plus the whole collection. It's as if I were suddenly allowed to be creative. And I just went whole hog.

The gay male point of view is extremely valuable because of the processes we have to go through. It is very painful to come out, to accept our creativity and to go as artists with it. I was totally attacked as a child. It was shameful to be slightly effeminate or creative, and creativity was effeminate.

I finally understood, I'm an artist, for God's sake. I can't wear brown loafers instead of black beano boots. There was a lot of stuff that had my creativity really frozen.

PHILIP JUSTIN SMITH
(playwright/performer)

When I got the PCP diagnosis, I was in despair. It's a death-sentencing consciousness. It's a word, and the word is *AIDS*. And it means "isolation" and "faggot" and "untouchable" and "disease" and "death." And on that intellectual ego level it just hurt, hurt, hurt.

I have bad periods of despair and anger and it's important that I just sit with it. For some reason, right now I'm the center of some energy, and if I can just sit with the emotion, I'm fine. But there have been moments where I've been exhausted by the responsibility. It feels like the longest one-man show I've ever done.

BO HUSTON
(novelist)

My main resentment about working and starting to get pub-
lished and successful and having AIDS, has been the fear that I'm
not going to get to mature as a writer. That the great book
someone writes when they're fifty, after years and years of work,
I'm never going to get to that point. That I'll die having been this
promising young writer and I'll never get to mature with the
work or with the career or with an audience that also matures.
Artists' careers are generations long, especially writers'. Writers
explore the same themes over and over again in more mature
and deeper ways.

I have one problem, which is how to cope with disease and
impending death because of AIDS. But really my main problem
is how to cope with life. I'm obviously doing better now than
before, but that's been my lifelong problem. Living. Fear of death
is one thing, and fear of life is really what I have to cope with.
Whether I have AIDS or not. I'm not prepared to be cured. Let's
say Salk announces tomorrow, "Here's the cure." I'm just not
prepared emotionally, financially, practically. I've geared every-
thing toward eventually and soon being ill and dying.

The challenging thing about AIDS is that it brings you right up
to confront who you are. And the more fragile and vulnerable
you actually become due to illness, the more immediate the
confrontation. You know how everybody walks around talking
about their "abandonment issues"? All of that is really expanded
and clarified when you really are afraid of being abandoned and
it's not abstract. I am really vulnerable now. I'm really afraid no
one will want me again, or who's going to take care of me? And
that's frightening.

I had a lot of pain associated with writing *Remember Me*. I was very sad and I'd get in this sad mood when I worked on it. I find writing very excruciating. It's the only thing I'm interested in, but it's not something that I enjoy. I just keep doing it because it's the only thing in my life that interests me.

Why this subject? One big aspect of this book [I'm writing] is about me still trying to figure out my childhood. It's very slow work, so I get closer and closer. It's about what decisions people make that help them cope with the pain in their lives. What's completely foreign is how people deal with happiness. The ending is very grim, which has not been my experience in the last few years, so I'm not exactly sure where it comes from. What I am moved to write about is really, really deep pain.

CYRIL COLLARD
(novelist/filmmaker)

Now I have the impression it's the writing that provokes the suffering, whereas before it was the pain that brought the words. Before, when I was in pain, from a broken heart or something else, I wrote. Now it's different; the writing seems so laborious to me, it has become painful in itself.

TIM WENGERD
(dancer)

I knew there was great power in learning how to do a contraction properly. A lot of people think, Oh, a contraction, who needs that? It's an old-fashioned sort of thing. It's old Martha [Graham] being weird and all that kind of stuff. And I'm there

saying, "You do a contraction when you have a baby, you do a contraction when you laugh, you do a contraction when you scream.' I said, "You can't discount this movement as some kind of abstract, bizarre thing that this funny old woman—who happens to be living longer than anybody else in the world—has discovered and made into a technique. I mean, this is about life, kids. And if you go that deeply into life, as a dancer, well, then you'll learn it." But I realize for a lot of them it's too scary. It's too frightening to confront a movement coming from that far inside the body.

PAUL MONETTE
(author)

Having been through so much horror, I couldn't feel anymore. I was afraid that it really was affecting my capacity to feel. As an artist, you reach for the pen that's full of blood. I feel that, for instance, in Reza Abdoh's *Bogeyman*. You try to find what it feels like. You try to find a voice to speak it. It's often very harrowing.

Roger always wanted me to go back to poetry, even in the midst of all that Hollywood nonsense. I used to say to him, "Roger, don't want me to go back to writing poems because something really terrible would have to have happened." And it did. And poetry was finally a way to express it. In the two or three months before he died, I wrote some very sharp poems. I remember saying to him, even four or five days before he died, "It's as if I never was a writer at all. Everything of mine is out of print. I can't write anymore, I'm too sad." The *Hardwick* decision [upholding Georgia's sodomy law] came down, which was a disgusting decision, with a very powerful dissent by Justice

Blackman, and I wrote a poem about that. It was three or four days before Roger died.

I remember being in his room when he was dying, and I said, "I don't know what I'm going to do without him." His doctor said, "You have to write about him, don't you understand?" Two weeks later, I was sitting in the cemetery before I went back to Massachusetts to visit my parents, and I realized that if the plane crashed, I would have left no record of Roger and me and what we'd been through. So that day, in the cemetery, I wrote a poem which was the first poem of *Love Alone,* and on the plane back to Boston the next day I wrote the second poem of *Love Alone.* That began a process that went on for about five months where it was literally all I did. I was working ten to fifteen hours a day. That book tells the story, very raw, about this strange world we came to inhabit because of AIDS.

After Stephen Kolzak's death, I bumped around for a month in great pain. I remember saying to my therapist, "Is there any way to speed up grief? Because I don't want to go through another two years of this. I don't have two years to go through this." And he said, "Well, no." I had already proposed an autobiographical work, so I knew I had that on my desk if I wanted to do it.

Becoming a Man was the hardest book I'd ever written. Writing the first one hundred pages or so, I thought, Everyone should do this. This really gets down into your past. I was really proud of what I'd done about my childhood sexuality. Then when I'd done about fifty pages more, and I'd gotten into my adolescence, I wanted to put a silver cross between me and the work. I felt I knew the reason all this stuff is dammed down inside you. During the next several months, when I was writing about the pain I felt at the age of eighteen, I felt eighteen again. I was very glad to finish it. In that book the writing resurfaced

the suffering. I don't feel it now, I think I purged it by doing it.

Becoming a Man is not a book about AIDS, but it's a book I never would have written had AIDS not been in my life. What I mean by "half a life story" is partly that you only live half a life when you're in the closet. But also that we're living in a strange age where somebody would write their autobiography at forty-five. Most autobiographies are written in the haze of older years; there's a sentimentality people feel just remembering that far back. I was really able to connect with some of the bad stuff, which didn't seem so long ago.

I'm still getting used to this, what it is to be living in a nightmare that's in my body and not just in people that I love. It's poignant separation and it's been angrily called a kind of apartheid, the difference between people who have AIDS and people who don't have AIDS. I think there is a great difference between having the illness and being close to someone with the illness. There isn't a great difference in pain. I think that our allies and our loved ones have gone through excruciating pain in taking care of us and watching us through it. I think that they have been as comforted by the art that has been produced by the AIDS crisis as people with AIDS have. You have to speak to them, you have to comfort them, and it's often very difficult for us who are ill to do the comforting.

Isn't it interesting that I find art comforting? I went with some friends to see *Bogeyman* and they didn't like it. They found it too upsetting. Life is too upsetting already, I don't need this, they thought. I just thought it was glorious.

REZA ABDOH
(playwright/director)

Anger is in my work as a cleansing agent. I don't mean that in a pedantic way, not as a cleansing agent that is cathartic or purging. I mean anger as an agent that propels you to take action. To write down your own rules, to make your own rules, to create your own universe. Which is something I'm doing more actively and consciously. For myself, it's to not lie to myself and to try to call things accurately even if it's impossible to do that. To try to, from my own perspective, debunk certain follies that I've had to accept as truth because of the conditioning you are forced to accept if you want to be part of a society that applies those rules. But then at some point I said I don't give a damn about that society. I don't necessarily want to be accepted by it and I don't want to be liked by it and I don't like it. Why should I embrace its constructs? Why should I look up at it as this formidable paradigm that will save me? There's no reason. I have to derail it. I have to create my own.

I'm afraid. I'm not afraid of dying or even of getting to a point where I'm disabled, a point where I'm not dead but I might as well be. Although the fear of a complete dissolution of the body is very real. It's more a fear of being disconnected from everything that makes me what I am at any given time. *Bogeyman* has a lot to do with that. I feel and see and think about things that might not seem connected to things that are easily grasped or digestible. And I don't really want to.

ISOLATION
AND ALIENATION

Furthermore, we have not even to risk the adventure alone, for the heroes of all time have gone before us. The labyrinth is thoroughly known. We have only to follow the thread of the hero path, and where we had thought to find an abomination, we shall find a god. And where we had thought to slay another, we shall slay ourselves. Where we had thought to travel outward, we will come to the center of our own existence. And where we had thought to be alone, we will be with all the world.

—*Joseph Campbell*
(writer/philosopher)

What is the source of the "disconnection" that Reza Abdoh and so many other artists living with AIDS refer to? How does this separation heighten an artist's inclination toward isolation? Does the artist feel a different, deeper aloneness after testing positive? How is his alienation magnified further by racial, cultural, or gender bias?

Just being an artist is itself alienating outside the large urban areas. If the artist is also ostracized because of race, ethnicity, sexuality, or gender, he can find himself doubly distanced from society, positioned far apart even before AIDS enters the picture.

AIDS disproportionately hits people who are already conspicuously alienated from the mainstream—most notably gay men, blacks, and Hispanics.

These are people accustomed to separation and discrimination—groups historically marginalized by society long before the AIDS epidemic.

What happens when AIDS is added to this already loaded equation? Is it another stigma to segregate one further from society? Does the double helix spoken about in the chapter "Artistic Exploration" become a triple helix? How much energy that could be used for working is wasted battling undercurrents of hostility out in the world? Does this bias sometimes fuel the art?

When the artist is part of a subculture or religion that judges his life-style or sexual orientation as morally reprehensible, the isolation again can be further reinforced. Being Chicano and Catholic probably added another level of guilt to painter Carlos Almaraz's feelings of shame about his homosexuality. Almaraz coded the sexual messages in his paintings for years; he didn't want his homosexuality seeping off his canvases into a life that, on the surface, appeared conventional and probably assuaged the isolation he felt elsewhere. Almaraz married artist Elsa Flores and had a child; he wanted his demons to stay buried, like the surreptitious sexual encounters that take place deep in the shadows of Los Angeles's Echo Park, a locale that was one of his favorite subjects. He covered his isolation with layers of shame and lies in much the same way he camouflaged his ambiguous subject matter with layers of thick, vibrant paint.

"You're dealing with a culture that prides itself on its machismo," said Richard Duardo, the publisher of many of Almaraz's print editions. The Latino machismo presumably would make it harder for a Hispanic homosexual artist to feel free to express his deepest emotions in his work. Already separated from mainstream American society by his Mexican roots, which he openly asserted in his paintings, Almaraz wouldn't risk alienating the public—or himself—even more by overtly embracing homosexual themes, too.

"Alienation is something that's always been in my work and that has been made more prominent by AIDS," said gay writer Dennis Cooper, who, though he has tested negative, has been deeply touched by AIDS, by the losses, the deaths of so many from his community. If isolation and alienation

are already important themes in an artist's work, does their importance increase?

If an artist worked in a collaborative medium like film or dance before testing HIV-positive does the need for community, to be part of a group, continue? Or, as Bill T. Jones noted earlier about his partner Arnie Zane, does the artist sometimes search for a more solitary expression? Does an interior life and intelligence flourish? How much of the outside world must the artist living with AIDS filter out in order to get all the work done?

By withdrawing, does the artist eventually feel more a part of "all the world"?

DAVID WOJNAROWICZ
(painter)

In the last ten years I've withdrawn. I hardly ever read, just nonfiction stuff periodically. I almost never go to look at what's called art. I actually haven't been up to the Biennial. I want to find out what I contain. I feel like I grew up in the first half of my life being totally affected by everything around me without a choice, and now, for the last ten years, it's been a process of going inward into isolation. I see people now and then, but for the most part I've been isolating myself and examining something inside myself, and looking around me and trying to understand and make sense of things in whatever intuitive way I can.

If you watch people, they spend their entire lives looking outside for things, whether they're creating books and movies or objects. I mean there are millions of different forms of distractions and entertainment. I don't see anything wrong with that, but going inward and looking inside, or exploring inside, is something I've been doing for years. It just seems like it would

be a lot more portable if I could find it inside my own head. This is a moment when the outside no longer gives me anything, or touches me deeply anymore. There's a sense of separation from everything around me. If this is a moment when I need to go inward, it's not that frightening.

I have ideas about how AIDS affected my work, or how AIDS affected how I view the world. It's like feeling like a stranger inside of my own life. I don't feel touched by things out there, and I haven't for a number of months.

I never thought I would reach a point where it doesn't make enough sense to do creative things. My creative stuff, at least for the last decade, made sense of living for me and gave me a purpose, it relieved stress in terms of this society. The more I was able to convey things to people through my work, the better I felt. The less alone I felt, the less alienated. It's been coming to a point in the last few months where I feel like I don't know if I'm going to work again. It shook me up. What else do I know? That's what I most care about—being able to work and make things, writings, objects, photos. In the last months, I came to accept it's a state I'm in that may or may not last a long time. It's not a negative or a positive; it's just what it is.

I don't feel a whole lot. There are some small projects I'm trying to gear myself to work on, some little things that are almost done, things I have to rewrite or images I need to collect out of different notebooks, somebody wants to publish a little book, things like that. I started writing a little when I was away out in the desert in the Southwest. I started keeping a small journal and it kind of woke [me] up a tiny bit. But I don't feel like I can truly drive it. I'm interested in whatever comes into my mind in any form—images, forms, words, thoughts, sensations—but I'm not feeling a terrific drive to map it down in communicable form.

PAUL MONETTE
(author)

The more I got into writing a novel, the more sense it made to try to look around and see beyond myself. That's why I have the Korean character and the Latino characters in *Afterlife*. To try to see what else this calamity was doing to people.

In the summer, fall, and winter of 1988 and 1989, I had met Stephen and it was what I wanted. The great change that happened for me as *Borrowed Time* was coming out was meeting him. I really had despaired about finding somebody. The *Borrowed Time* press tour was a terrifying and terribly upsetting experience. It's hard to believe this four years later, but in many cities I'd go on radio shows and the callers would call in and say, "You deserve this," and "You should die of this." I've known about the hatred out there for a long time, and I've tried to speak to it here and there, but that was the first real experience I had of it. It was dismaying to go back to those hotel rooms. I had bronchitis and I had hurt my back, and I would stand eating my supper off the dresser and think, Why am I doing this? I know I produced a really good book, and I felt a sense of triumph and pride having left that record of me and Roger, but life just seemed pointless.

I've said over and over, I'd rather be remembered for loving well than writing well. Being in a relationship has always grounded me in such a way that my writing has been a joy to do. I think that comes from all those years of loneliness, and all those years of being in the closet and writing those ascetic poems that frankly say nothing except how lonely and sad I am. Who cares? I can't read those things anymore.

Coming out of the closet saved my life. I think if I had not

come out of the closet, I might have sat writing those lonely, oppressive, depressive poems for years. By the time I left poetry behind at the age of twenty-eight or -nine, after I met Roger, my feeling about most American poetry was that it was about nothing. Once I came out, the gay world was what I felt the urgency to write about. Thank God I had my poetry before that, because I don't know what I would have done. That isolation can really kill you, it can lead you to that drama which ends in a black hole.

STEVE BROWN
(filmmaker)

I've been very, very withdrawn. I'm much more introverted compared to a year ago but not in a scared or timid way. It's more like I'm working on myself, trying to do my writing, trying to get this done. I don't go out much. I see a small group of people and they are the same people that I've been seeing for ten years.

I think that honestly, at this point in my life, I feel less a part of the world than I did before. I don't know if it's a result of the HIV-positive thing, but I don't feel particularly engaged with the world like I was before. I used to find a lot of things that gave me pleasure, little things I could get involved in, like spending a day looking at rocks in New Jersey or at some small town. I don't have a lot of pastimes now, I just work on my film stuff or AIDS activism. I don't feel in touch with the world.

TORY DENT
(poet)

After testing positive, perhaps my poems became graver. But it wasn't like I was really happy before. I came from a background of much confusion and suffering. Being a severely battered child in an upper-class East Coast privileged background, I had problems just coping. Early on in my twenties, I was seeing a therapist for a long time. So a lot of my poems were about pain and alienation, very similar thematics to what testing brought up. The synchronicity, the odd "karma" of testing positive, to me is that in some ways I've always felt HIV-positive. I felt the ways in which people who are positive are treated in this society. That's how I felt treated in my familial environment and how I felt treated in the community in which I was brought up at large. And then to test HIV-positive was a really grand irony. Once again, it wasn't something that was really wrong with me but how I was perceived. That direct rejection that I felt one-on-one from my mother, who battered me, suddenly became a ubiquitous property of the world at large and how people perceive AIDS.

I wrote art criticism in college, and when I tested positive, my mentor urged me to write essays again. He encouraged me to start trying to work in a less isolated way. Because poetry is quite a hermetic existence.

I think loneliness is the condition of life, and when I feel close to people, I'm not lonely. That loneliness, that sense of alienation, can be put to a third or fourth dimension by testing positive.

JAMIE MCHUGH
(dancer)

Feeling a part of humanity has been a constant struggle all my life. Whether to be in this society or to be out of it. My life theme is about being an outsider. What and who is my community? Is it the world of artists? Is it the world of dancers? Is it the world of leftists? Spiritualists? Where do I belong? I don't really know. I think ultimately I feel that my family is the human family. Illness is a great leveler. It's hard to feel separate when mortality is staring at you. That's been a great lesson for me, feeling my own mortality.

If anything, I used withdrawal more before I was diagnosed. I isolated. I lived in the woods. I was very comfortable to be off on my own. My spiritual side was much more developed than my emotional side.

REZA ABDOH
(playwright/director)

I think the impulse to redefine yourself because of an agent that is invading you is a very strong impulse. But I think it has been important for me not to permit that redefinition as a tool for self-pity or a tool for a self-discovery that detaches me from myself, from my body, from my pleasures, from my pains, from my sex, from my psyche, from my spirit, from my work.

ESSEX HEMPHILL
(poet)

I entered the *Brother to Brother* project after Joe [Beam] died. "Complications related to AIDS" is how his certificate is listed, but there are questions that have remained with numbers of us about the silence, about how he was found. Just as we live and in our living provide examples, in our deaths as well there are examples that we leave.

Joe's body was found in his apartment. There was no reaching out on his part. There was a lot of shutting down, a lot of withdrawal, like the way elephants pull away from the pack when they're wounded, sick, and ailing. It was that sort of thing, and we—meaning his friends and the community who supported his work—didn't understand that this was a potentially fatal process he was going through. I guess if we had known we would have been more aggressive, maybe some one of us would have kicked down the door. I run into people who knew and saw Joe days before he passed and they all were aware that something was going on. But how do you reach into someone's defense system?

I learned that silence is very traumatic. His death was truly a catalyst for me exercising one of his sentiments—"that black men loving black men is a revolutionary act"—in terms of finishing *Brother to Brother.* We need to be there for each other whether or not there is a romantic element or something to be personally gained.

ROBERT FARBER
(painter)

One of the hard things about being HIV-positive is that it's undeniably necessary to get support from the people around me when I feel troubled, because otherwise I feel so horribly alone and scared. And it's not easy for me. I like the life-style of an artist, spending six, seven, or eight hours a day alone in my studio working; I have a streak of misanthropic guardedness about me. My painting gives me a lot of solace, but when someone tells me that my T cells have dropped to 290 even though I'm on AZT, we're not talking about a painting anymore, we're not talking about making art, we're not talking about anything theoretical, we're talking about my fucking life. And at that moment I don't give a fuck about painting. All I want is somebody to stop this disease.

EDMUND WHITE
(novelist)

I finished *A Boy's Own Story* in '81, so it was in no way affected by the disease. Then, after that, I wrote *Caracole,* which came out in '85, so that was very much a product of living in Europe. Everything in the book is transposed from my own experience; in other words, it's the opposite of an autobiographical novel. There are no gay characters in it, for instance, and it's not clear where it's taking place or in what period. So it's a bit hard to see in it any direct reflection of my own life. But I think that nevertheless there is a feeling of doom that hangs over the book. What I was feeling in those years was extreme isolation. I was living with an American in Paris, neither of us were tested, but we both

imagined we were positive. And we were hearing about friends dying back in America.

PETER ADAIR
(filmmaker)

In some ways I'm tuning out things I didn't used to tune out. Now the problems of the world upset me more than they used to, so I tune them out as a matter of self-preservation. I'm not doing any more filtering than before, it's just that the filtering's less effective.

I used to live in New York and I left because I didn't want more input. I've never lacked for ideas. I've had too many. In one way, I feel myself shutting down, focusing more on ideas I've wanted to deal with rather than opening up to more input.

LARRY KRAMER
(author)

The reason I go away to write is because I've been very active politically and it's hard to separate oneself from that. Activism is very seductive. It's a way of feeling that you're doing something positive to save your life.

And writing is very lonely, and although I don't mind the loneliness, you don't get the immediate response that any of it is going to save your life.

MARLON RIGGS
(filmmaker)

To paraphrase something that James Baldwin said when a journalist asked him how he felt when he began to write "black, homosexual, poor," I hit the jackpot with HIV. I knew I simply had to use it. When you're dealt what might be considered a bad hand, you've got to transform it in such a way that all that is considered a handicap becomes a virtue, a means of empowerment. For me, as a cultural worker with certain explicit ideological and political agendas, it's not only empowering in helping my community, but also in helping me deal with those demons inside.

So much of my life had been about effacement, self-effacement, pretense, masquerading, concealment, and indirection. Partly, that has to do with what it means to be gay or lesbian in this society and a person of color, particularly when you are seeking some form of "assimilation"—I use that term in quotes—into mainstream society. When you are seeking empowerment and enfranchisement in the society, it requires that you negotiate with dominant cultures, whether straight, or mainstream African American, or whatever it is that has held you back.

The process was cathartic. I can't describe what it is to have lived much of your life in a prison in which the bars and the jail cell are invisible because you have become so accustomed to them. The way you can open a door to a rat cage, and the rat will not exit because it is so accustomed to those barriers, it assumes they are still there. In many ways, that had been the quality of my life, as I know it had been the quality of so many other lives of black gay men. I discovered that I had, in part, imposed the barriers, and been complicit in my own oppression, and that I could end it in a word, namely by speaking. That is why the

documentary is called *Tongues Untied.* It was almost earth-shattering in what it taught me psychically about the power of speech and the power of self-affirmation and the power of an articulated self-identity.

Would you have gotten to that anyway?

Very slowly. I am by nature a very cautious person. I'm a southerner; I was trained not to be impulsive, impetuous. My personality expressed itself in a way that never directly confronted anything; even when I confronted something, it was more of a passive-aggressive than a direct style. My work dealt with issues of race, representation, power, and how representation imagery functions within the power dynamics of different groups in society: blacks and whites, privileged and underprivileged, straight and gay. But implicitly, I wasn't in any direct way dealing with sexuality at the time.

There was a way in which my work was following a logic, it was clear, and my life itself has been affected by friends and family members dying, my own lover. There was a progression to addressing issues of sexuality, and then AIDS and how homophobia and race intersect in an epidemic to worsen the condition, particularly if you're Afro-American. But that would have occurred very slowly. It is occurring in a glacial manner for so many people of African descent in this country, even those who consider themselves politically progressive. It's another thing on the menu of struggle with which we have to deal, something we don't want to have to consume, ingest, and in some way resolve in our lives. People simply push it aside like it's some hideous vegetable that a child imagines to be poisonous. Like a child, you imagine all the evil it will do to you if you ingest it. Dealing with AIDS among many of us, particularly people of color, is the same thing, except it's a real poison and not dealing with it is a problem, not a solution.

IMMEDIACY
AND TIME

[To] hold infinity in the palm of your hand
And eternity in an hour.

—*William Blake*
(poet)

Does the artist's perceptions and feelings about time change after testing HIV-positive? Is there an acceleration of thought and productivity? Does he experience a period of soaring imagination, of racing output? Does the artist feel more compelled to produce? Does he worry there will never be enough time to get everything done?

I witnessed a quickening of the creative pulse in my friend Kenny O'Brien as he undertook one project after another. When he was already fighting full-blown AIDS, after he finished building his house and scaled down his design business, he found other outlets for his creativity. He started gardening. Not ordinary gardening, though. He called it "painting with flowers." Did this new obsession have something to do with the passage of time, with

the seasons? Was it ironic that he suddenly turned to a palette that is inherently ephemeral?

There wasn't enough time to finish, or even start, all the activities O'Brien had planned. His last fashion show was held days before his death, while he was in the hospital undergoing a tracheotomy.

Keith Haring was equally driven. He continued to rearrange the elements of his imagination into fresh and frightening visions. "I was in his studio and he whipped out seventeen drawings in one day," recalled photographer Herb Ritts, whose black-and-white portraits were incorporated by Haring into some of his last works. Haring and Ritts had a show together in Atlanta a few months before Haring died. "They were all on the floor, watercolors, very stark, and there was one piece I kept looking at, which was these birds with broken wings that were sort of falling. It was very linear and noncluttered and in a different style. These birds with the wings being snapped off."

Do periods of creative urgency alternate with moments of creative blankness when the artist turns away from his work completely?

Jewelry designer Tina Chow found out she was HIV-positive when she got sick during a business trip to Japan. Despite her failing health, she continued to travel and work nonstop. Her bold and unusual jewelry became even more spectacular; she added metals to her palette of bamboo and crystals. She also began sculpting in stone.

Does the preoccupation with time influence the selection of materials, such as Chow's choice of metal and stone, elements that are resilient to time's passage? Do thoughts about time—which can imply dynamic concepts like movement and speed—generate excitement and energy in the work? Or do they provoke feelings of languor and loss?

In some of Haring's later paintings there is a frenzy, an exhilaration. The canvases are active, jammed with mesmerizing images—witches weighed down by half a dozen pendant breasts, hangmen, erupting penises. The observer's eye darts over the surface. Haring defies the eye to slow down and stay focused on any one impression. In places, the paint itself is in motion, splattered. The *Apocalypse* series has the same defiance as Reza Abdoh's play *Bogeyman,* in which the set, a brick facade of an urban apart-

ment house, is the frame for explosions of action occurring simultaneously within various rooms, a conscious manipulation of time by the playwright.

Carlos Almaraz's last black-and-white sketches—masks, skulls, stick figures—are marked, literally, by the passage of time. You can clearly detect the rapid movement of the pencil over the page by the way the stroke is etched in the paper. You can almost feel the urgency behind the application. The drawings, though void of the intense colors Almaraz used in his oil paintings, are equally alive and vibrant.

"Carlos worked constantly in the end," said Almaraz's wife, Elsa Flores. "He was incredibly prolific. He did the work of two lifetimes; he wouldn't stop. We'd come into the studio—he was very weak and thin, it was very hard for him to walk—and he wanted to work on these huge paintings. He was determined. He'd sit on a stool, or take a break or take a nap, but he was constantly working. In the hospital, up until the end, he had sketchbooks. He did these incredible drawings during his last hospital stay until he died."

Edward Stierle, the Joffrey Ballet's daring young soloist, threw everything into his dancing after testing HIV-positive in 1987 at the age of nineteen. Anna Kisselgoff, the *New York Times* dance critic, noticed the next year how Stierle "had made a breakthrough in his virtuosity and depth." It was after Stierle began to have health problems that he made the grueling transition to choreographer. His last ballet, *Empyrean Dances,* was premiered just three days before his death. Gerald Arpino, the Joffrey's artistic director, noted how Stierle had used his perception of limited time to concentrate his creativity. "I think the knowledge that he was facing this finality opened his inner eye even sooner and crystallized his intentions," Arpino told the *New York Times.* Arpino went on to say that probably Stierle would have arrived at this same level of achievement eventually. But how much longer would it have taken?

In what ways does the artist feel driven to seize what he can use, what will enhance his message, and discard or reject what does not serve him? Does the artist feel pressured to leave his mark? Is there a move toward autobiography?

And, if the artist with AIDS at first races to get everything done, does he eventually enter a period when time seems to drag? Snails crept into Italian painter Vittorio Scarpati's imagery, growing larger until they filled the entire page. In one of these snail drawings that Scarpati did right before he died, he has written the caption "Here is a representation of time at its worst."

Ideally, it seems, an artist should have all the time to do everything he is inspired to do.

And not a minute more.

LARRY KRAMER
(author)

I have to write my novel because if I have five years left in my life, I'm very lucky, and it's going to take me five years to write it. So I have to be very harsh. I do actually look at my days now in a harsher way. If I don't do something on the novel, or if I'm not reading a book of research, I feel guilty. I simply cannot waste time daydreaming, feeling sorry for myself, reading a book for pleasure unless it's a very good one, the kinds of things we all just take for granted.

I'm making the choice of putting the writing in front of the activism because I think my days are numbered. Immediacy has entered the picture in the last year and half as my T cells have started to decline and I've had peculiar periods of not feeling well, indicating to me that whatever it is, is knocking at my door. I've got to be more serious about the creative work. And this long novel is the only thing left that I want to write. I feel very much that I will be writing it until I die and then it will be finished.

CYRIL COLLARD
(novelist/filmmaker)

AIDS brings what's potential into reality. Regarding time, it provokes an acceleration and a more pressing rapidity in what one creates. In Keith Haring's and Carlos Almaraz's work, there was almost a bulemic reaction in their production. I think with writing and cinema it's a little different; one just can't proceed as quickly. A painter does his canvas and he's finished, or a photographer takes pictures. A book obligatorily takes pretty long; even a book that's written very quickly takes at least a few weeks. And film, well, that's another story.

A painter who starts a painting, even if he's sick, he knows that he's probably going to finish it. The guy who starts a film—well, it can take a year, three years, four years to make a film. So that's a difference. He might get sick in the interim. The idea of thinking that you'll never finish it might make you not want to start it in the first place. It's different in each creative domain. Take the case of someone who wants to write a historical novel. That could be at least a thousand pages. He might never start for fear of never arriving at the end.

Before, I took notes, like a journal. But I usually used these notes much, much later. In my first book, for example, there are things that come from notes that I took five or six years before. Now I can take notes at night, and the day after I might use them in the script. The time that passes between the notations about reality and the reuse of this reality in my art is much shorter. It's as if the juncture between the realistic and the artistic is much more immediate.

I've always felt a creative urgency.

JAMIE MCHUGH
(dancer)

Some of the things coming out of the AIDS crisis are really wonderful. The crisis has worked on two levels, both an art and a life level, and I think that interface is what's really exciting. AIDS and HIV are totally different states of minds. For those of us who are HIV-positive, it's totally different than having AIDS. For me it's a wake-up call, it's about the immediacy of life.

Right now I'm struggling with my inertia and my sense of acceptance: accepting things as they are versus that other part of me that really wants them to change. I got very comfortable in terms of living my life. But there's another part of me, my life-force and my passion, that feels there's something more. Something that has to do with the courage to create. I'm struggling. Part of me just feels sick of this virus being in my body. I'm sick of it, of it always hanging over me. I feel limited.

I realize the blessing of this illness is that it has moved me in directions that I didn't know were available. It gave me a sense of immediacy. But there's also that sense that crisis requires change. Things can't just remain the same. That's both exciting and scary and I feel that change, that movement, is the real basis of creativity.

REZA ABDOH
(playwright/director)

My reflexes are sharper. I'm more adamant about absorbing ideas and facts and images that I feel have an urgency.

MARLON RIGGS
(filmmaker)

There is the knowledge that you may not be here tomorrow to say, "I love myself," and "I love you," and "I love this life and this history which has shaped and moved and inspired me as an African American." [The knowledge] that we must begin to transcend all the differences which have mired us in hatred of others and self-loathing. That we can begin to even confront HIV and see it as another part of our struggle as African Americans, people who have continually confronted adversity and attempts at genocide in one way or another, benign or deliberate ways in which we have been dehumanized. We can look at all we've gone through and now use that to battle against this virus. Not the virus as some personification of evil; I hate to do that. I hate to privilege and to anthropomorphize the virus in that way, or to make it satanic. But rather to battle against all the ways in which our society fears and projects evil onto the virus in a way that we, too, become contaminated and looked at as contagion. Or worse.

ROBERT FARBER
(painter)

Going through this dark, dark period, time took on a very particular quality. I don't have all the time in the world anymore. So I have this sense of wanting to use my time as well as I can and do as much as I can. I'm much more prolific and I'm less anxious about it. I know I'll come to my studio and this or that will happen. If I spend most of the time today puttering or doing prep work, I don't flagellate myself for wasting time. I know I

needed that. I know I needed that time to let whatever's going to germinate germinate. I don't feel like I'm wasting time in the ways that I used to.

The only thing that I can imagine would give me relief is to be in an absolutely bland, large room and just stand in the middle and do nothing. That image, which is very strong for me, is about eliminating all stimulus, all temporal signposts as if I were out of time. That would be the only place where I would feel I could alight. The room is a place where there are no problems, no problems because there is nothing there.

These raw canvas paintings relate to that empty room. It's the most fundamental material, nothing's on it, it's not adorned, it's not even primed. The canvas I'm working on now started as this naked linen with the word STOP in dead center. And that really made me stop in front of it.

This is really hard. Although I get tremendous pleasure out of things in life, this knowledge of my illness and what's probably in store for me makes it feel like there's no relief, no place to rest, to feel carefree. I just want to stand in the middle of the room and say, "Could we just stop this now? Have I done enough of this?" That's where the STOP paintings come from.

The only thing I know is that if I get to my studio, that means I'm alive today. And being totally alive and bringing that to my work is very valuable in my mind. Every day that I have in my studio I bring as much of myself as I can to whatever's in front of me. In doing so I am saying I am here today. Because there is going to come a day, sooner than I expected, when I'm not going to be here. That's the currency I'm trading in now. So what's of value to me is to be here as authentically and as totally as I can.

❖

I have this new confidence. I'm not painting about something. I'm living it. It's much more immediate and therefore I trust whatever's going to come out of it.

KEITH HARING
(painter)

The hardest thing is just knowing that there's so much more stuff to do. I'm a complete workaholic. I'm so scared that one day I'll wake up and I won't be able to do it. . . . No matter how long you work there's always going to be things left undone. And it wouldn't matter if you lived until you were seventy-five. There would still be new ideas. There would still be things you wished you would have accomplished. You could work for several lifetimes. If I could clone myself, there would still be too much work to do—even if there were five of me. And there are no regrets.

PAUL MONETTE
(author)

I knew my own status and I expected, any day, to wake up with a lymphoma. My immune system numbers were fairly stable and I had started some antiviral medication. I felt a real sense of urgency that I'd better write, there was no time to waste. One publisher suggested that I write *Borrowed Time* as a novel in the third person the way Christopher Isherwood wrote his memoirs, but that's not what I wanted to do. I just wanted to write about Roger and me.

But you later did chose to write *Afterlife* as a novel, in the third person.

Yes. After *Borrowed Time* I thought, I can tell this story as a

novel. I had this idea of the three widowers. So I started that. And between finishing *Afterlife* and starting *Halfway There,* I don't think there were more than three or four days. It was all a flood of work.

BO HUSTON
(novelist)

I wanted to be a writer. And by the time I got diagnosed I had three or four years sober. When you first get clean, they tell you that you have all the time in the world, and then I was suddenly told that's not true. I felt this real urgency about wanting to fulfill what I thought I was good at. I'm sure there was ego in there, and then part of it was that it's my truth. That's what I do. I don't want to die working as a secretary with a drawer full of short stories. So I pushed and I pushed.

I learned that with my situation of having AIDS hanging over my head, I had a lot of work to do. I don't have time to struggle through a lot of the processes. I need to have some acceptance of life now. I guess that's what I mean about maturity. I have to mature as soon as I can. I don't know how realistic that is, probably not at all.

I just want to finish whatever I'm working on.

STEVE BROWN
(filmmaker)

AIDS brings things into focus. I've come to see how too much thinking stops me from doing. When I think too much I start

getting insecure. I'm not ruminating over things anymore. AIDS has forced me to put things in order, things that have been kicking around for ten years. There have been a lot of unfinished things in my life. If one thing is relevant to the HIV thing, it's that I'm trying to bring closure to everything that I feel is of value.

Testing positive made it necessary for me to make a decision about how to proceed with my life. Not the rest of my life, but my life from now on. If I really want to do something, I should make an attempt to do it now because I might not have a future. I feel like the decisions I make now are really going to influence the next few years, and the next few years might be the only really productive time that I have left. And even if that isn't true, even if I'm asymptomatic forever, I will have taken responsibility.

DAVID WOJNAROWICZ
(painter)

I think I kind of emptied out in the last year. I really drove myself hard and finished the book [*Close to the Knives*] in a month and a half. I did an entire show of photographs and paintings and just pushed myself relentlessly. Then I got really sick when the show was up. It was the last thing that I did.

Suddenly I didn't have the luxury of time. I don't know, but it made the world a little more marvelous than it ever was before, it was like I found myself at a tremendous distance looking at the world I live in.

Time fluctuates. It expands, it contracts. I know it's a joke, the idea of a metered sense of time. Time doesn't function that way. It's a creation probably for the work world. When you're in a

situation that's incredibly threatening, time can expand so that you feel the fractions of a second in terms of movement, your body, the heartbeat, all those things. Other times you can go through experiences where time is so fluid and so quick that the sun's setting before you know it. I feel like I've been trying to break down all those walls, all those false notions, all those barriers and structures, because they do affect how we experience everything mentally and physically. I want less and less separations. I try to put that into my work more and more.

RICK DARNELL
(choreographer/performance artist)

I don't know how long I'm gonna live, but I've never known that anyway. Now, I get to really be careful. It's like being baptized, like being washed in the blood. It's like, "Man, you've got to get your shit together because you've got this thing in your blood, in your body." There are those people who have this whole ACT UP agenda, working through consensus, going to meetings. Well, I go to rehearsals instead.

SYMBOLISM

I search in these words and find nothing more than myself, caught between the grapes and the thorns.

—*Anne Sexton*
(poet)

Are there specific symbols that emerge in the work produced by artists who are living with AIDS? Does the image of being "washed in the blood" that Rick Darnell spoke about in the previous chapter recur in the work of artists experimenting in other media?

When our view of the world changes, when our perception is altered, as in times of war or plague, we often revert to basic, archetypal images in our expression. It is an unconscious way of finding comfort and equilibrium in a shifting time and environment, of anchoring ourselves within a changing reality. At times like this, symbols from the collective unconscious surface on a conscious level. One of the most fertile realms for exploring symbolism is the sphere of creation.

How have these artists dealt with their feelings about AIDS in a symbolic way? Does an artist turn to symbolism when feelings about his condition are sublimated or denied?

One symbolic thread running through much of the art coming out of the AIDS epidemic is a loss of innocence. It is evident in many of Keith Haring's later drawings, collages, and large-scale works, in which he used illustrations from children's books, photos of himself as a child, and children's artwork to explore childhood and emerging sexuality.

Another common thread can be seen in Haring's humans, including his crawling "radiant child." Some of Haring's forms seem to have evolved from the half-human, half-animal mythical figures, also portrayed on all fours, found in ancient cultures. Haring used a recurring squared-off barking dog that is very similar to the coyote in Carlos Almaraz's painting *Fear*. In Almaraz's work, the symbolism, especially around the human form, also comes from ancient imagery, often Aztec and Mayan sources. Humans appropriate their energy from the animal kingdom. They dance with animal masks or are infused with the energy of the animals they ride. It is a physical, sexual energy.

Almaraz's iconography, already fertile, expanded when he became ill. "Once he became aware of his mortality, the symbolism was more focused on leaving this world. He was more aware of how fragile life was," recalled his wife, painter Elsa Flores. "The symbolism [already] had a similar thread running through it for twenty years that now seems almost predestined. When he became ill, it all came to the forefront. The piece *All the Ships That Sailed Before Us,* from his last show, had many references to his demons, to past sins committed, judgment, punishment, purgatory, being saved. A lot of angels, hands of God reaching down from the sky. Many serpents started appearing in his work. He was exploring medieval symbols for death. He often used a burning wheel."

When the artist has a potentially fatal illness like AIDS, do stroke and symbolism become bolder like the line in *Apocalypse,* Haring's collaboration with William Burroughs? In that series of paintings, based on Burroughs's cataclysmic saga, the decorative touches previously associated with Haring

are gone. Space also takes on new meaning. The gesture—wherein lies the passion—is strong, assured.

Do certain symbols—blood, fire, body fluids—take on new meaning seen in the context of AIDS? When an author living with AIDS writes about a couple making love or even about a child cutting his finger, can it ever mean the same thing? How does the tension of opposites—a tension between living and dying—manifest itself in symbols?

Is AIDS too abstract to be understood on anything more than an intuitive level? Are the symbols used by artists living with AIDS a means of expressing something for which a verbal explanation does not yet exist? How are these symbols—pulled out of *khaos* and mysteriously organized in the creative process—helping us to understand this crisis and, ultimately, ourselves?

STEVE BROWN
(filmmaker)

I am surprised at the obsession I've had with blood, because I don't like bloody movies, I don't go and see horror movies. But in my screenplay about the girl who brings people back from the dead, there are two major bloody scenes. There's somebody dying, covered with blood, all this blood is pouring out of him. Then I have the whole Jesus Christ fantasy where he's bleeding all over the place. I've got this whole blood thing, which I never realized I had this fascination for.

ROBERT FARBER
(painter)

In the *Western Blot* series, I use blowups of the AZT molecule. And this is a depiction of what the actual suspension looks like on a slide of HIV-positive blood. If those three bands are evident

on the slide, it means the person is positive. Here it's meant to
suggest a headstone, a tombstone. I found I could use that
technique to achieve the speckled effect of the three bands,
which represent three of the envelope proteins that identify HIV.

This is an electron-microscopic blowup of the HIV molecule.
I decided I wanted to use more laboratory imagery juxtaposed
with the medieval. Because medieval art was so infused with
symbolism, it gives me license to use it without explaining it or
apologizing. I think I'm using symbolism both consciously and
unconsciously. "Ret Rovi Rus." I separated the word *retrovirus*
into "Ret Rovi Rus" and I used Times Roman font to make it look
Latin.

I've begun to incorporate these panels. This empty one sug-
gests a funeral announcement that's bordered in black. I'm creat-
ing these multipaneled pieces that suggest an altarpiece and
using these quotes and elements—like the ornate and gold-
leafed moldings—that would suggest some of the art of the
Middle Ages. I had been looking at medieval heraldry banners,
and that brought to mind jousting, chain mail, and that kind of
thing, so I started hammering some nails in.

I'm struggling with trying to make this work more personal
and intense. I'm looking for military images to make silk screens
out of, images to do with war, fighting. It was suggested to me
through one of the quotes of a Franciscan nun, an AIDS care
provider, who talks of the bravery and courage of those people
she treats. It made me think about the war that I am fighting on
a lot of different levels.

The triangle that I use is not only the gay SILENCE = DEATH
triangle but, at the dawning of the Renaissance, there was a
return to basic geometry. From the ornate heights of Gothic

architecture there was a return to fundamental geometric sim-
plicity. Part of the reason why Gothic architecture fell apart is
that it could only be executed by master masons. And since a
third of Europe was killed in the first wave of the Black Death,
most of them died. So they had to come up with an architecture
that was easier to execute. Here I'm transforming the triangular
shape into the actual Gothic point.

RICK DARNELL
(choreographer/performance artist)

Brides of Frankenstein has these beautiful painted backdrops,
all in flames. And in the panels, in back, are little triangles with
eyes above them; they're a takeoff on the fag pink-triangle thing.
We performed it at Laney College and it was a bad scene. They
had put a disclaimer up in the lobby about the backdrops and
nudity and foul language.

The whole thing about *Brides of Frankenstein* is that we are
married to death. Clyde, one of the dancers, is supposed to be
Cassandra, Priam's daughter. She saw the future but no one
would believe her. That was her curse.

REZA ABDOH
(playwright/director)

The very first thing I did after I found out I was HIV-positive
was a video called *Sleeping with the Devil.* I became a lot more
conscious of the body, the excoriation of the body as a tool. And
I consciously—or unconsciously—infused the piece with that
idea. I'm preoccupied with the body and with shit and come and
all the other stuff. I like to concentrate on excavation, excretion,

things like that. I think it has something to do with the diagnosis. But I don't think I'm concerned with that only because of my condition. There are a number of ideas and concepts I'm concerned with and excited by that aren't necessarily linked to my condition. But my condition informs me, my psyche, my mentality, my sexuality, my being. It's not something that I can look away from or put on the sidelines or not make a part of, in some way, everything I do.

BO HUSTON
(novelist)

The small town is a recurring theme with me. I was born in a small town and we left it when I was about seven. My earliest memories are of this really small, picturesque, Mayberry type of small town. Then we moved to the suburbs of Cleveland, but I was always struggling to get back to this small town and wanting to construct ways to give me that form even though it can be a very sinister environment. Small towns can be very ominous places when all the craziness that goes on is suppressed. The conclusion is that no place is safe. That town and the idea of home surface for me a lot. It's not even conscious. My themes are about home and travel from home, and home again.

CYRIL COLLARD
(novelist/filmmaker)

At the end of *Les Nuits Fauves* there's an important geographic thing that happens vis-à-vis the south, the sun, and the light. Nine-tenths of the film takes place in Paris, a city of pressure, heaviness, inertia, encasement. Then the protagonist goes down

to Portugal, which encompasses the idea of the extremity, the tip of Europe, the tip. I want to keep the idea of him feeling a part of the world, the feeling of being alive and that the world around him is no longer external to him. He has a desire to participate in the world, which is, all of a sudden, being offered to him. I don't want to say that all of a sudden we're menaced by death and we turn toward the sky and God. It's more subtle than that. But there is an openness to certain ideas and sensibilities; it's about spirituality. It's not a religious feeling. It doesn't have anything to do with life after death. I don't know if there's an afterlife or reincarnation or anything, I don't know.

I'm drawn to the sun and the Arab countries, the southern Mediterranean. I'm also drawn toward the theme of leaving. *Condamné Amour* is a long story of leaving. In *Les Nuits Fauves,* the protagonist leaves at the end. It's always there. Departure can be an escape, but for me it's the idea of perpetual movement. Movement as a moral point of view. We move not to get trapped. So in *Les Nuits Fauves* he moves toward the sun.

FREEDOM

And one alone will speak of being
born in pain
and he will be the wings of an extraordinary
* liberty.*

—*Frank O'Hara*
(poet)

For the artist, can AIDS mean new creative freedom? Can it push him to reveal in his work facets of his personal life and feelings previously withheld? Does testing positive mean the time to dare, to take risks?

Many of the artists I interviewed were young gay men who were frequently forced to hide their sexuality in society. As a result, they sometimes became distanced from who they really were and even began seeing themselves as the people they pretended to be for the benefit of the outside, often judgmental, world. That disguise often carries over into the art produced within the gay subculture; probably it sometimes intensifies the work. It is not unusual for a gay writer or choreographer to embody a homosexual love story in a heterosexual couple, as Tennessee Williams often did. In

making his first film, *Grand Huit,* novelist and filmmaker Cyril Collard identi-
fied with and projected himself into a female protagonist. Although Peter
Adair was always forthright about his homosexuality, he never included
himself in his early films, not even in *Word Is Out,* a documentary about gays
coming out of the closet. As he spoke about in the chapter "Artistic Explora-
tion," Adair boldly changed his style after testing HIV-positive and made his
own story a vital part of *Absolutely Positive.*

Does the creative spirit expand when parts of the self that were previously
edited out of one's art are put back in?

As mentioned in the chapter "Isolation and Alienation," Carlos Almaraz's
need to keep his sexuality out of his paintings added another layer to his
isolation. "The garden [in Carlos's paintings] is Echo Park. That's the center
of a lot of activity for the Hispanic community in Los Angeles," explained Jan
Turner, the eponymous owner of a Los Angeles gallery that handles Almaraz.
"People get married there, they have their children's christening pictures
taken there. It's the center of the community, the male/female, and it's also
apparently where he contracted AIDS. So when you know that about the
bridge and the water and Echo Park, it's a whole other scene. But, of course,
in paintings like *The Mystery of the Park* and *Moonlight Bridge* it comes out
looking like a Technicolor movie, and life is a lot like that too."

After Almaraz found out he was HIV-positive, though, his secrets sprang
forth, exploding in paintings like *The Struggle of Mankind,* which depicts two
men violently making love. It was as though there were nothing left to hide,
nothing left to lose. His art exploded with newfound freedom.

Why do some artists perceive AIDS as an opening to artistic freedom, yet
others never take the risk of self-revelation? When the artist tests positive, is
he free to be more direct in his work? Can he drop abstraction and impene-
trable symbolism? Is there less of a dichotomy between what belongs to the
public realm and what belongs to the private?

At Beyond Baroque, the old Venice, California, town hall that is now a
performance space, I heard a young poet read a moving verse about not
being be able to tell his parents that he was gay and HIV-positive. What he
wasn't free to voice in his life, he could disclose in his art. Testing positive

I, in a way, had it all. And I didn't want anything to interfere with that, I wanted to control it all. I realized that some things are unmanageable.

ROBERT FARBER
(painter)

Being HIV-positive has given me a tremendous amount of freedom. I've cut loose a lot of chaff, a lot of weight in my life. It's also given me artistic freedom. I can enter the world of these paintings and virtually whatever comes out of me is going to be usable somewhere in it. Also now I judge things by whether they're going to be a life-giving experience or not. And if they're not, I try to let them go.

JAMIE MCHUGH
(dancer)

I realized part of healing was about being more expressive and really getting out what I was feeling, getting it out through my body, with words, speaking it. Like that old gospel thing that the truth will set you free. And now I really know what they mean on an energetic level. There's such incredible freedom just to say, "This is who I am, this is what I have. In all my strengths and weaknesses, this is who I am." When I'm willing to be more out there, that feels like true creativity. It's really opening up a lot of possibilities in my life. That whole idea of the life/art process, and that the material of our life is the source of our art, can really deepen our art. To me that's really important. Okay, I've done this dance. What meaning does it have in my life? What's the purpose? And that's the bottom line. Burt Supree, the dance

critic, wrote this wonderful article and talked about how dance started feeling really irrelevant to him when his lover was dying of AIDS. That he would have to leave his lover to go out to review somebody who was doing the same old bullshit. And when I read that it was like, right on, that is really the bottom line.

EDMUND WHITE
(novelist)

The way I've railed against political correctness in this interview, I never would have done that in the past because I was always very, very diplomatic. I never had any enemies. Now I have tons of them and I don't care, I honestly don't care.

STEVE BROWN
(filmmaker)

I've always been ridiculously critical of myself. Part of the reason I have all this unfinished work kicking around is because I thought it wasn't good enough. I'm much freer now, a little bit easier on myself. I have the attitude that not everything has to be perfect. If it expresses some idea or truth, or some reality of what you believe, and if you can put it together in a way that doesn't embarrass you, then you should put it out.

I'm thinking about somehow bringing AIDS into my work. I feel more courage. In the context of HIV, I'm willing to take more chances and put myself out there. I don't care what people think. There's a lot more self-acceptance, a lot more self-love. I accept myself. Finally.

REZA ABDOH
(playwright/director)

I'm not necessarily less critical but I feel less hampered by self-inflicted taboos. Or societal-inflicted taboos. I don't feel the burden as much. I've made my peace with myself. I've said, "Fuck it. I'm going to do it this way, and who cares what anyone else says!"

PAUL MONETTE
(author)

The more passionately I have written about the subject of the calamity of AIDS, the more aware I've become of the threat to our First Amendment freedom. We are much closer to a kind of subtle, flameless book burning than we've ever been in my lifetime or that we've ever been since the Nazi book burnings. Terrible people full of hate and distrust are our leaders. They have gone after artists in a completely cynical and ignorant way. Someone is trying to take our freedom away because we are trying to tell the truth.

One of the things that keeps me going as a writer is knowing how profound my enemies are and how powerful they are. I often say that the greatest book we have since the Second World War was written by a fourteen-year-old girl and the forces of evil have spent the last forty-five years trying to say that book is lies, that it was all made up, that there was no Anne Frank. I'm heartsick at how the hate has taken over. AIDS presses so many buttons about other things that people can't handle: death, sex, intimacy. Within this subject are all subjects. It's not that I think of artists as a community of saints at all. But what I love is that

we are tenaciously our own selves. If I didn't have all those constraints to fight against, I'm not sure I would have felt such creative urgency.

I think I'm something of a romantic. I have to work against the sentimentality, but I'm someone who really believes in love and I really love to tell a love story. The challenge of trying to write a love story in the midst of a holocaust and in the midst of so much bigotry is the right challenge for me.

TORY DENT
(poet)

Cruelly, after testing, I was pushed to a deeper level of artistic freedom. I just didn't care as much about the perfection of a poem, I had so much to say.

CYRIL COLLARD
(novelist/filmmaker)

After an artist says, "I'm HIV-positive," he can say anything. When that taboo has been swept aside, shame or modesty no longer exists. When one says, "I'm HIV-positive," he goes beyond his internal creative barriers. Barriers that can come from Christianity, from his upbringing, or from the artist's unconscious.

Censure and autocensure exist a lot less. I'm much less sensitive to criticism by anyone, a reviewer, a politician. In my case, I never really had barriers in this area. But I think it reinforces the absence of autocensure and the nonacceptance of the censorship of others. I'm sure of that. There's a real sense of freedom, liberty.

✦

The other day I saw a slogan on a wall: "Art lives from free-dom," which is totally false. It's exactly the contrary. Art lives from constraint and dies from freedom. Pure art, essential art, comes out of situations of extreme repression. And AIDS is a form of nonpolitical repression, it's a psychic repression. The artist can experience this as an oppressive and repressive event that makes him want to create in order to prove to himself his freedom, his immortality.

An important thing for me in this idea of *Les Nuits Fauves* is the idea of liberty, of freedom. You enter a space and a time that is no longer controlled by laws and power, by the hierarchy, but instead by pacts between individuals. Everyone is on equal foot-ing. The only law is the law of desire.

SEX AND SEXUALITY

It is up to sex to tell us our truth,
since sex is what holds it in darkness.

—*Michel Foucault*
(philosopher)

When the artist with HIV or AIDS explores the law of desire, when he uses sex and sexuality in the content of his art, does he once again find the creative consequences intensified? Is the already doubled helix of the artistic process magnified in another way because of the often sexual transmission of the virus?

Some gay artists, like choreographer Rick Darnell, had only just begun to openly examine their sexuality in their life and their art when the AIDS crisis jolted their experimentation. When sex and sexuality become loaded pistols, do expressions of denial, anger, guilt, and even self-loathing appear in the work?

"Because of his Catholic upbringing and all of the guilt surrounding sexual-

ity, it was like he felt he deserved this," said Elsa Flores about her husband, Carlos Almaraz. "It finally got him, he felt like he was being punished. Intellectually, he understood the rhetoric of religion, but the little boy in him fell for that old line." The darkness and shame that Almaraz associated with his sexuality permeated his paintings in somber, jarring colors and castigating images of the devil or the Grim Reaper.

What happens when an artist living with AIDS explores sexuality in less abstract and symbolic terms?

When America, reeling from the AIDS crisis in 1989, took a good look at Robert Mapplethorpe's photographs of leather-clad gay men in sadomasochistic poses, the repercussions were startling. Although the pictures were taken years earlier, Mapplethorpe, always openly gay, had only recently come out and acknowledged that he had AIDS.

In Washington, D.C., the Corcoran Gallery of Art canceled Mapplethorpe's show, *The Perfect Moment*, while in Cincinnati, a county grand jury indicted the Contemporary Arts Center and its director, Dennis Barrie, for daring to go ahead with their scheduled exhibit of it. Eventually Barrie was acquitted, but not before a censorship battle had been inexorably linked to art in the context of AIDS, and to sexuality—especially homosexuality—in the context of art.

If factions of society have difficulty accepting any art that is explicitly sexual, will they ever embrace work—whether sexual or not—produced by an artist who has AIDS and who, most likely, got it from either sex or drug use?

Artists, especially gay ones, often make a connection between the sexual force and the creative one. "I've always used sexual energy to write," stated Dennis Cooper. "I tend not to have sex when I'm writing; it's part of my process. And that had always been the case." Despite testing negative, AIDS has altered the way Cooper, a gay male, uses sexuality in his novels. "I began to write much longer things," he said. "I decided to really make sex the center of my work. It always was, in a sense, but I'm not sure I would have used it so much. Since it no longer affected the explorations in my life, my work became a substitute."

Is this also the case for artists living with AIDS? Is sexual energy channeled into the work or used to fuel the creative process? Does creative exploration sometimes become a surrogate for sexual experimentation? Are sexual exhilaration and risk sublimated in the artist's work? Is the art sometimes more daring as a result of this displaced sexuality?

Can art be a form of safe sex?

EDMUND WHITE
(novelist)

I think one of the biggest struggles if you're positive, as a person and as an artist, is to keep sex in your work. Everybody wants you to get rid of it. They all think there's something unseemly and horrible and nasty about it. Basically the idea is, "You got yourself into all this trouble in the first place because you were so promiscuous, plus you infected other innocent people. Can't you please just stop all that nasty behavior? Haven't you learned your lesson yet?" That's basically the attitude.

Felice Picano wrote an article in which he said he felt there's a whole new generation of gay writers who have betrayed themselves because they don't ever talk about sex. I remain sexual in my work and it gets me in trouble with everybody, but I'm going to keep on doing it. People don't want to hear about it and they don't like it. [But] it's the life energy.

I think it's a good thing when life and art approach each other. It's something to be explored that people really haven't done enough. Robert Glukes said to me that he had put his salary into one of his stories and everyone was so outraged. They didn't mind if he talked about having sex with his father, but you're not allowed to mention your salary. And there are millions of things

like that that people are too ashamed to mention, or they don't consider it appropriate subject matter for fiction. I think it's a constant source of experimentalism for a writer to try to think beyond those taboos, which are almost unconscious, and figure out how much more of his life he can get onto the page with it also being entertaining. That's the other thing, how to keep all this stuff interesting.

The truth is, when I wrote *A Boy's Own Story,* it was a huge best-seller all over the world because it was about childhood and adolescence, the time before a character decides he's really gay, or just as he's trying to be. *The Beautiful Room,* though it's a better book and got better reviews, sold considerably less because it was about gay people. That means a very restrained audience. With the book I want to write next, if you add the whole element of AIDS, that should reduce the interest still further. I'm not writing primarily to make money, so I don't care, but somehow if a writer feels his audience is shrinking with each book, he's slightly nervous about it. Taking on AIDS at all is a way of condemning yourself to obscurity.

I'm doing this biography of Genet. It seemed like a good thing to write about one of the greatest writers of the twentieth century whose life is almost a total mystery to everybody. And he was really one of the pioneers of gay fiction. *Our Lady of the Flowers,* which he had already finished in 1942, is the first time that I know where a novel is gay, where there's no effort to explain how the characters became gay, no effort to diagnose or to apologize. It's a very liberated point of view because once you get involved with trying to give diagnoses of why people are gay, you've already admitted they are ill and that they need some explanation. Heterosexual authors don't go around talking about why their characters are heterosexual, which is equally hard to explain. Genet was the first writer to actually show gay

life as it takes place in the ghetto. Middle-class gay writers before him, like Gide or Proust, tend to show the gay couple apart from the gay milieu. Genet was the first one to show the milieu and to write autobiographical fiction in which there's a character called Jean Genet, who himself is a homosexual, what's more a so-called passive homosexual, shame of shames. It's a very liberated, fearless act of courage, written by a working-class man with immense intelligence and erudition, about a working-class world of prostitution, thieving and begging that he had known. Well, calling it working-class is a bit much; it's actually sub-proletariat.

In America it's all lobbies and special-interest groups, single-issue groups, it's rather pathetic. To me, Genet and Pasolini are the two most divisive gay artists of this century because of the broad range of their interests. They also, incidentally, never denied that the reason they were mainly interested in these other [socioeconomic] groups was sexual. Americans are so puritanical, they think showing that somebody has sexual motives is enough to deny the validity of their effort. Genet and Pasolini both reversed that. They said that unless you have an erotic interest in the people you're helping, your interest is phony and hypocritical. It's all about desire. Pasolini was brilliant, and again, somebody who was from the peasant class.

ESSEX HEMPHILL
(poet)

In the novel you see two of the characters play out their sexuality in total disregard for the time that they're living in. You get ruminations of what's motivating the behavior. At the same time, I've tried to be sure that the sex itself is palatable, that it's

real. That if nothing else, we remember that it was like this at one point, but that it can't be like this anymore. We understand what risks these two characters are running to have this moment basically out of context now. I haven't run away from sex in the work. It's still very much represented even in the recent poems that I've written. Even in writing about the riots in Los Angeles, there's sex in there. The sex becomes a metaphor for the riots.

Yes, I'm HIV-positive, but there's still a world out there and things that I've lived and witnessed. There are things that I remember and there are things that I can't do anymore. There's all of this swirling around and I just reach my hand into what's swirling and pull out of it and work with whatever it is I pull out. I'm not policing my experiences; I'm not even the least bit interested in that. That's been some of the problem all along: the policing and the reinforcing of various sorts of silence. So if nothing else, I've been about eradicating that with the strength of what I've witnessed and what I try to write about.

CYRIL COLLARD
(novelist/filmmaker)

I was very impressed by what Georges Bataille wrote about the link between erotic expression and creation. For me, whenever I write, the sexuality is very present and very strong. I'm not saying you hold the pen in your right hand and jerk off with your left. But it's very close. For me, it's very driven. And I need to speak about these kinds of things in my work to be myself. Ecstasy can also be converted; sexual and erotic ecstasy can border on the spiritual. There's a moment when you can go either way. There's an image I've always liked: it's the idea that when you make love with someone, one's sexual organ is looking for the soul of the other, the idea that at the core, you touch

the soul. There's a French expression: *corps et âme,* "to lose body and soul." For me, it goes without saying that you can't separate the body and the soul. The soul is inside, in the guts. And the sexual act is the search for the soul. I've felt that, I believe that.

In art, having a quest is absolutely essential, too, so as not to fall into artistic conformity. It's like oxygen. I don't know if the sexuality affects my work on a conscious level. It's a calling, it's something imperative, it's an impulse.

In the first film I made, *Grand Huit,* I projected into the woman's character because I didn't yet dare to write from a male point of view. I didn't dare present my homosexuality directly. Strangely, *Les Nuits Fauves* affirms my emotions of virility, something I've been experiencing for the past two or three years. Not to say that before I was effeminate, but I hadn't really embraced the idea of virility. And now that's been clearly affirmed. Which doesn't mean a loss of the feminine part of me, just that I'm more conscious of the masculine part.

I'm still attracted to the perverse. The idea of *nuits fauves* [wildcat nights] came about because of AIDS; it's an escape. The *nuits fauves* are about an unwedged sexuality; they're about humiliation, depravity. It's as if AIDS made all the fantasies that were hidden inside come to the surface. The *nuits fauves* have to do with a quest. A kind of sexual grail. For me, the *nuits fauves* are about ritual and about the sacred. But then one becomes diverted. Little by little, one realizes one is looking for love in a place where one finds only sex. I know that I never found love there, it was sexuality.

BO HUSTON
(novelist)

Sexuality was a big part of writing when I started writing. Maybe that's true for a lot of gay people. I started writing when I was ten years old and it was an immediate fix. It immediately started filling a need. It's almost like you're writing to get yourself off. A lot of the writers that I've been most interested in over time have been writers who are on that balance beam, like Genet. Writing is about fantasy. It's about really digging deep; that's what writers do. I don't understand enough about other art forms to be comparative about it, but I know that's what the process of writing is about. And a huge part of that is sex.

I don't like gay stories, gay life-style things. It's not that I don't like writing for gay people, or being a gay writer, but I don't relate to the context of a story that is about, by, and for gay people. Isolated in that way. I've always been interested in trying to make my gay male characters' sexuality as incidental as a straight person's would be. It's the difference between Fassbinder's *Fox and His Friends* and the American film *Making Love*. Fassbinder's story was about betrayal and who's stupid and who's smart and all these complexities. The story was very rich and you didn't walk away thinking that you had seen a story about gay people, any more than with *Maria Braun* you thought you were seeing a story about heterosexual people. I'm not pushing away the idea of a gay sensibility, either; I think that's inherent. It's not something you calculate. You either have it or you don't. I have people in my work who are gay, they are homosexual. The men want men, or boys, whatever. And how to work that, without that being their "problem," has been interesting to me as a conscious formal concern.

STEVE BROWN
(filmmaker)

I never really did art until I got to Harvard, and it happened at the same time that I realized that I was gay. I started finding what was inside of me. I made my first movie, *Echo,* and afterward we had this little critique where the teacher said to me, "This movie, the symbolism is very sexual, very erotic." I had never even thought about it until after I did it, but it was basically all about me finding out that I was gay, which was a nightmare. It's about me dealing with that secret side, that other side, that I'd avoided for such a long time.

ROBERT MAPPLETHORPE
(photographer)

It's not sexy taking pictures of sex. I wasn't doing it for that. I wasn't getting off on it, . . . I was just obsessed with it. I was just going to do it one way or another. Basically, I'm selfish. I did them for myself—because I wanted to do them. I wanted to see them. I wasn't trying to educate anyone. I was interested in examining my own reactions. There were certain pictures I took, certain areas I went into, that I decided were not places I wanted to be. There were other places I stayed in for periods of time. I was experimenting with my own sensibilities. I was finding out about myself.

PETER ADAIR
(filmmaker)

I'm always embarrassed by sex in films. I guess I'm a prude. In the first place, it's almost always heterosexual sex, and I was brought up with that. Maybe that's where I began to think it was boring. I think porn is boring. Conquest is interesting, romance is interesting, but as soon as it starts involving something deeper than kissing . . . there's nothing more ridiculous to watch than fucking on the screen. Whatever kind. It's not erotic to me, it embarrasses me.

The feature I'm writing alludes to sexuality subtly and I would like to allude to it more. It's not politically correct to talk about the relationship between gay liberation and the epidemic, but there's clearly a real relationship. But, at this point, the film is a comedy.

DAVID WOJNAROWICZ
(painter)

I asked him about his painting *When I Put My Hands on Your Body,* which was part of the 1990 Whitney Museum Biennial. Maroon text is arranged in symmetrical horizontal lines over silvery black skeletons. The passage tells of touching another's body, of feeling the flesh and sensing the other, or perhaps himself, fade away.

It's a piece regarding a close friend who is becoming more and more ill. I lost a good number of friends over the last few years. It's about dealing with my own mortality, dealing with his mortality, dealing with living in an unconscious society, dealing with a whole range of things. It was just something where I picked up a pen and wrote it in a few minutes one afternoon. It's not just

me and a lover, it's me and my friends, the people I love, the people I feel great loss over in terms of them dying or coming so close to death. It's an emotional state. It's like wanting to give somebody something and in the end just pulling back and seeing time and history and everybody's mortality. Not just the person I'm referring to in the text.

ROBERT FARBER
(painter)

This sense of poison being just inside my skin made me feel very unattractive. So my libido just took a hike. But since I felt that being with someone wasn't going to change anything, what I held on to was my work. The reason to keep going was to paint about this stuff. I could afford to let go of relationships and sexuality because I had a *raison d'être* outside of that.

RICK DARNELL
(choreographer/performance artist)

AIDS is not a pretty way to die only because there's shame attached to it. There's this whole stigma. It's hard enough being queer. It's hard just being an "out" queer. Then this.

The thing that's cool about AIDS is that it's broken the last taboos on sex. What holds us down is the power struggle between men and women and that's going away. Now that I'm no longer in the warehouse performance scene, I'm meeting more straight people, which has opened up a whole new way of discussing sex. Sex is going to set us free. Break the taboos, learn to love each other, then learn to remember each other when we're gone. Through our art, too.

✧

I'm doing a piece called *Falling*, about the fall, the decline, of this uptight straight white male power thing. The piece is multicultural, polygendered, polysexual. Very inclusive of everyone, but underlying everything is sex all the time. Because that's ours.

I want to make a piece called *Fetish*. It's all about code signals. You know the hankie codes? Like a red hankie in your right pocket means you want to get fisted. I'm going to make a piece based on that, a postmodern thing which extends to how we read codes and signals. It's going to be real political; it'll be a little bit of gay culture and gay history from the time when we had to hide. Thank God people aren't just tops or bottoms anymore. We're people. Sexual things.

MARLON RIGGS
(filmmaker)

I felt that so much in *Tongues Untied* would offend so many different people, even black gay men, because I was including drag queens. I was doing it in a way I hoped would be affirming, but drag queens for many gays is total no-no. They are "those" people. We're not "that," we're real men. We've internalized many of the dominant cultures notions of masculinity and enact them among ourselves and thereby create new oppressions even within our own communities. I wanted to eliminate that through the work, so that we could begin to embrace the totality of this community and of ourselves as black gay men. So that we could claim our femininity, if you will, and not have to wear yet another mask of black gay masculinity.

✧

The tendency when talking about homosexuality in majority culture is to deal with us politically or culturally, but in a way that sexuality—actual sensual touching, the physicality of our identity, what we enjoy doing, which in part defines our identity as gay men or lesbians—gets left out, because that in many ways is the most threatening. Most documentaries and many films that have dealt with homosexuality represent us as not touching, never kissing or embracing. We look at each other, we long for one another, but there's no frank acknowledgment of what makes us gay. I'm not saying that one has to have the contact of genitalia to be defined as gay. I think that sexual identity also hinges on psychology, yearnings, fantasy, desire, even the repressed feelings that are associated with homoeroticism. But, nonetheless, we don't normally even get that far in much representation of our lives in film and video, including those done by us ourselves.

So for me, it was essential in *Tongues Untied* that I not repeat that. That I not make this work easy for straights to consume by erasing our sexuality as physical people engaged in physical intimacy, and also that I not make it in a way that would comfort many gay men who have internalized the idea that overt physical embrace or intimacy is taboo. I can't tell you how many gay men were offended by *Tongues Untied,* who felt that there was too much sex in the documentary. There's no sex in the documentary. There is eroticism and sensuality and the camera very lovingly caresses black male bodies. It's clear that there is desire there, and there is a sensuality in the camera movement across arms and legs and chests. The poetry is extremely erotic at times—again, I think in a way that's tasteful, sensitive, not simply laying it all out as if it were plumbing. But it talks about ignored emotional sentiment that lies behind touching, the excitement, the tension, the desire.

And there's the final climactic scene that deals with two men who are embracing lovingly in bed, which created shock waves among straights when *Tongues Untied* aired on public television: two men kissing, two black men kissing, with beards! These weren't sissies, at least not by appearance; these were the kinds of guys that you could not easily label as gay because they do not look it. They look like your brother or uncle or your son. For that reason, people were really shocked out of their complacent stereotypic emotions about who is gay. Normally, black men are not associated as being gay in the popular culture, but even to blacks who were gay, these men looked so much like anybody else.

Throughout the work, which deals with the politics of our identity, I had to make sure that I did not have this discussion on a detached critical or intellectual level, that infused throughout was the affirmation of sensuality, physicality, sexual love, particularly in the age of AIDS. This is implicit throughout the piece. I wasn't directly saying, "Don't believe the hype about HIV, self-hatred, and controlling and policing your desires," but implicitly there was the affirmation of the healing touch of one man to another. It culminated in that scene that created such hysteria, which, in so many ways, is so tame compared with what you would see among heterosexuals on prime time or soap opera television. But nonetheless, since it's two men, it's seen as diabolical in many eyes.

Since *Tongues Untied,* in my other work, I've found it necessary to constantly affirm this, not necessarily in images that are overtly erotic, but in the storytelling or in the use of the camera. How the camera focuses on more than just the eyes, the head, the mouth when people talk, how it moves across the body, to remind people of this body that is speaking to you. It is not simply a head; there is a full person with sensation. And I have people touching themselves and moving their hands across their

arms, and necks, chests. Not in a way that's masturbatory, but sensual. It reminds us of a need to constantly connect with our sensuality, our sexuality, with our physicality. So much of the culture tells us that psychologically we're pathological but physically we're vermin and not to be touched or to touch. And particularly in that context, it's necessary to constantly remind ourselves that we are not an abomination.

The previous films were talking-head documentaries, very analytical, Aristotelian almost. I'm proud of them still. They were designed to do certain things for certain kinds of audiences around certain subject matters. But nonetheless, there was a level of safety in that form and definitely an absence of exploring that taboo sexual side.

In *Ethnic Notions,* which was a documentary about the history of antiblack caricature in popular culture, I wasn't even really conscious of the omission. It is a documentary that looks at racist imagery, and there has been so little historically that deals with how homosexuality functions as a part of racist caricature. There is much about sexuality—heterosexuality, the savagery of black men who, of course, are out to rape any white woman no matter what she looks like simply to control and abuse white privilege; the voracious sexual appetites of black women, the open and willing vagina for anyone who comes along. I was dealing with those myths, but because I was dealing with what was present in the popular culture, overtly rather than implicitly, homosexuality or bisexuality didn't come into the analysis.

And moreover, I didn't really think about it because, in my own life, in my own self-identity, sexuality was simply a private matter at that time. I really did not bridge the notion that, just as race is not simply private, that there is history that surrounds one's personal racial identity which shapes that identity, so there is history, social forces, notions of family, community, power,

and representation that surround sexual identity. That it, too, is not simply an enclosed private sphere in which we can act out who we are in the bedroom. I was very much of that thinking.

The gates were starting to unhinge before I got sick, but again, very slowly. I had been reading Essex Hemphill, a black gay poet. I had been reading *Other Countries,* a collection of black gay essays and short stories. I was aware of Joseph Beam's *In the Life,* another anthology of black and gay writing, and *Tongues Untied,* the anthology that came out of England of black gay poets, American as well as British. In my own private life, I had become part of a black gay men's support group designed to help us deal with all kinds of issues which we had neglected in our lives. With all this movement, there was the recognition increasingly that sexual identity was more than a private thing, that it involved community and society and history.

In *No Regrets,* I also wanted to address the body. This is a documentary that talks about HIV, AIDS, and coming out around this part of our identity, but not simply in the political sphere. It also talks about it in terms of lovemaking and sexuality. At one point in the documentary, in a very frontal address to gay men, particularly black gay men, one of the interview subjects addresses the camera and says: "Go ahead, love your bodies, don't just believe in sucking, sucking, and fucking. There's so much more to do, like talking dirty and jerking off and wrestling." Normally those kinds of things get left on the cutting room floor, particularly when the documentary is designed to go beyond a smaller community. It was important for me to affirm that no matter where this documentary might go—and I'm not clear where it will; I never thought *Tongues Untied* would make it to broadcast television—that all

of who we are enters the public discourse and we don't compartmentalize our lives, police parts of ourselves in order to find acceptance among ourselves, let alone within the majority culture.

POLITICS
AND ACTIVISM

The victim who is able to articulate the situation of the victim has ceased to be a victim—he or she has become a threat.

—*James Baldwin*
(author)

Is the art being produced by artists living with AIDS a vital tool of political activism? Since issues of sex, drugs, race, and gender are inevitably associated with the work of an artist who comes out about his medical status, can it ever *not* be politically charged? How is this work influencing—for better or for worse—government art policies?

"When artists become ill, they're not just fighting the illness," stated Patrick O'Connell, director of Visual AIDS and himself HIV-positive. "They're fighting the society, they're fighting stereotypes, they're fighting prejudice, they're fighting hatred, and they're fighting indifference."

Can an artist effectively fight this indifference through his art?

Some of the first examples of "AIDS art" came out of anonymous collec-

tives like Boys With Arms Akimbo, Gran Fury, General Idea, and DIVA TV (Damned Interfering Video Activist TV), who often used the strategy of appropriation to make their point. Gran Fury parodied the Benetton clothing ads featuring interracial couples kissing; Gran Fury's poster, with a hetero-sexual couple, a gay couple, and a lesbian one, read: KISSING DOESN'T KILL: GREED AND INDIFFERENCE DO. One of the most dramatic uses of appropriation was General Idea's sequence of paintings based on painter Robert Indiana's vibrantly colored, four-letter iconoclastic LOVE symbol. Using the same pop-art typeface, General Idea substituted AIDS for LOVE.

This anonymous outpouring of political art paved the way for individual artists to risk original, signed work. Artists like painter and writer David Wojnarowicz completely blew the lid off anything "safe"—regarding the message or the messenger. Artists came out from behind the guises of collective voices and began making personal political statements.

One of the first exhibitions to assemble an important collection of art about AIDS was Witnesses: Against Our Vanishing, a group show curated in 1989 by photographer Nan Goldin at Artists Space in New York. It included pieces by artists who were HIV-positive, like Wojnarowicz, as well as work by artists who had already died of AIDS, like painter Vittorio Scarpati and photographers Peter Hujar, Mark Morrisroe, and Robert Mapplethorpe. "I wanted to do a show about my community, and in order to do that it had to be about AIDS," explained Goldin, who for several years had been photographing her "tribe" of friends, many gay and ex–heroin addicts like herself. The exhibition consisted of personal reactions to the AIDS pan-demic. Obviously, given the nature of this illness, many of the pieces were also overtly sexual.

The National Endowment for the Arts, which had given Artists Space a grant for the show, threatened to pull out due to the exhibit's politically (and sexually) charged agenda. Foreshadowing what would eventually become successful efforts by the art world to unite against the AIDS crisis in projects like Day Without Art, a group of New York artists protested. "What actually happened is that Leonard Bernstein, in support of the show, refused the Congressional Medal of Honor," recalled Goldin. The NEA, to avoid embar-

rassment, finally backed the show but pulled funds earmarked for the cata-
log, which included an explosive essay by Wojnarowicz, "Postcards from
America: X-rays from Hell." The catalog was eventually underwritten by the
Mapplethorpe Foundation.

Obviously, there are segments of American society that will not tolerate
art that depicts, with passion and intensity, life-styles and life choices that go
against the grain. To make matters worse, the *Witnesses* show was mostly
photography, not abstract or ambiguous art. "These problems with censor-
ship in this country really underscore the truth. If those photographs by
Robert Mapplethorpe and Nan Goldin's exhibition at Artists Space had been
about women tied up in rubber, nobody would have said boo," commented
O'Connell. "But rather, it was about gay men, about gay and lesbian sexual-
ity, so people wanted to shove it under the rug. That strong a reaction to the
work assures us that art can change things, otherwise they wouldn't care so
much. We wouldn't be so unsettling." With all the heat generated over art
about AIDS, it is as though the censors feel that the work itself is a virus from
which the American public must be protected.

Does art have the power to evoke response when it addresses the social
context of the illness? When it confronts the homophobia, racism, classism,
and sexism that have blocked our country's response to AIDS?

If, as Rilke wrote, passion and necessity are prerequisites to making great
art, can testing positive itself become an artist's creative fuel? Does AIDS
activism often become the centerpiece of the artist's work? Of his life?

"These artists are making art that's right in your face, you can't avoid it,"
asserted O'Connell. "It's not art that's rooted in formalist concerns. It's art
about immediate experience. It's art that's about some ugly truths."

Does this art have the power to change those truths?

RICK DARNELL
(choreographer/performance artist)

I have an agenda now and my agenda is this: AIDS. There's only one answer to AIDS, and that's a cure that's available to everyone.

I'm in a really great space to make dance. I've got this great company. We do everything ourselves. We want to avoid the bureaucracy that happens when you get bigger. Our rap is down, our battle is down; we can talk about this thing. We've got the discourse. People fly us all over the country to these political things, these gay festivals. It's really hot. You see all these people together and everyone is talking about AIDS and work is being made around AIDS.

What's happening now is that the white heterosexual male power structure from the West is fading out. That's not what the world is anymore, certainly not this country. It's just that those guys hold the money. They officially hold the power, they hold the arms. That's starting to fade, and you're starting to see a real multicultural thing that's reflected in the arts.

I think it's important for people to come out about their status. Especially in their work. "I'm positive," "I'm negative," or "I just don't know." Any one of those is a perfectly good answer.

The very first dance we did—and one of the most powerful ones—was *New Danger*. I've always been political because I'm an anarchist. People should rule themselves. *New Danger* has a chain-link fence that separates us from the audience, and all these things happen behind this chain-link fence. Things like being held back, being suspended by chains, things dealing

with fire, water, washing each other. It happens in solos, trios, and quartets. Then at the end of the dance we come out from behind the chain-link fence with spray-paint cans. One person sprays *L*, another person sprays *O*, one person sprays *V*, and one person sprays *E: LOVE*. There are four guys with *LOVE* on their chests. And we start telling the audience, "I love you, I love you," and we rap with them. Then we spray-paint *HATE* across our backs. So we're flipping back and forth, "I love you, I hate you, I love you, I hate you," and the letters are jumbled. It's about how love and hate are the same thing. Then we take our shirts off. And we spray-paint, with red paint, on our chests: *AIDS*. It's a direct challenge: What are we doing about AIDS? Do my parents know about it? Do my friends know about it? The whole time we're rapping and talking with the audience, and then we say: "We've got to do something about this," and the lights go out.

When we toured around the country with *Art Against AIDS*, something happened in the community. There were other people doing the same thing. And these big-name art superstars, who sit up in their little ivory palaces and collect their royalties, got their work out. People had never worked like this before: people made new work; it got people thinking. *Art Against AIDS* was the dictionary about making art about AIDS. Not only art about AIDS, but art of response. Because AIDS is about oppression.

Alvin Ailey dies of a "rare blood disease." Well, it's just not that rare. It's so lame that they still aren't copping to the facts, because you know what? He was a black man, and the black community is being ravaged by AIDS. Homophobia is racism. Racism, homophobia, sexism are the exact same things. There are all these people who looked up to Ailey. He was a hero, a

role model. So let's talk about what he died of and how we're losing these really wonderful people to AIDS. It's betrayal. Point-blank.

No matter how beautiful the art is, it's got to be really clear that it's about AIDS. I say AIDS. People need to walk out of the theater more often. It's not the TV.

The first time someone ever walked out of one of our pieces was when we did a piece called *Sleep with Reason,* which is all about the NEA and censorship. We talk about the first time we were censored. We burn a flag and get naked on stage and at the end I take these Polaroids of Nick, who's totally naked, working his tit rings, working his cock rings. I make these photographs and give them out to people. They have this little thing that develops and suddenly they have pornography. This dyke walked out when Nick got naked. I was mad. I expect to be supported by a dyke. And the piece is so unoffensive. It's way clever.

People need to walk out of the theater. It's got to be like *Rocky Horror,* where they yell shit back. Because theater is there to change our lives; it's there as a record of what's happening. That's art.

For me, dance has always been a search for community. I've never been interested in solo work. Community is about finding people you fit in with, people who by their very existence and their work are making the world better. What's happening now with this community, and with AIDS, is there's room to do work and the work is supported.

For the longest time political dance was just goofy. It wasn't clear; it was cliché. It wasn't really contemporary.

❖

I don't need NEA money. It's dirty, tainted money. I couldn't think of a better time to be living or dying than right now. The world is changing. And with this NEA flack, our history isn't being recorded. We need our queerness. Everyone's history has to be told. Queers blew the whistle on the NEA. Queers blew the whistle on AIDS.

There was this Mozart festival, *Mozart in His Time*, to celebrate the two hundredth anniversary of his death. Mozart was a drunk, he was a liar, he was an addict. He was a tool. He was a great dude, totally abused by the patronage system. They were like, "Dude, write your music and split. We'll put our name on it." He died in poverty. But you don't learn that in school. I wanted to find out that Mozart was queer, but he was just a drunk womanizer. He was into other people's wives.

Here was this festival, with tons of money, and not one thing about AIDS. So, *Homozart*. The piece is a biased deconstruction within the context of AIDS, a time parallel between two hundred years ago and now. Christine, the dancer, makes these parallels about death. It sets people up for AIDS, it's really blatant. In one part of the dance, Mozart is in one part of town locked away in this room writing his *Requiem* and he is dying, he has a virus. And across town his wife has the same thing and they can't be together while they are dying. What a rip-off! He loved her and they couldn't be together.

That happens now all the time. Someone's parents come in, your buddy's dying of AIDS, they can throw you the fuck out and there's nothing you can do about it. That's changing a little now, but the point is that you want to be with your friend who's dying.

Homozart is eventually going to be a memorial project. We've got to have history here, we've got to have our myths. The fire is HIV, the fire is oppression, the power is sexism. In *Homozart*,

there's a piece of moldy bread. If Mozart had penicillin he would have probably lived. Then Christine brings out a bottle of AZT and clippings from the newspapers. The World Health Organization, which is so shady, predicts that by the year 2000, forty million people will have HIV. If everyone who had HIV suddenly had a blue dot on their head, we would be shocked. We'd all go out collecting pennies for AIDS. It's a time bomb. And the second wave is coming up. People are going to be dying.

ESSEX HEMPHILL
(poet)

James Baldwin's commentary about hitting the jackpot by being black, poor, and homosexual was a flippant statement fully signifying on the dichotomy he found himself in at the moment the question was asked. Asked by a white male, one who represents what Baldwin does not have. So by saying, "I hit the jackpot," we obviously have this rhetorical moment going, where he's trying to see his identity as equal to and as powerful as the identity putting forth the question. As a rhetorical strategy, I think it's probably just a little flippant. It's grand, but the reality is I don't think there's a jackpot no matter how the combination sets itself up. There's no jackpot regardless of whether one is black and gay or black and lesbian or white and lesbian. When we are talking about moving forth from a space of sexual identity, a politicized space, the jackpot is the least of things that's available for you then.

I often find myself saying that I treat my own HIV infection in the same way that I treat everything else that I contend with as a black male so that I don't overprivilege and overdramatize my HIV status. What that means for me is not losing sight of the

other things that might be immediately more destructive or costly to me because I'm a black male living in America. That's been a strategy born out of reality, born out of not inflating the moment and perhaps losing my balance. Born out of looking to strike an even ground with myself wherein I'm concerned and caring for my health physically, spiritually, and mentally. It's about my identity as a black person and what it means to maintain that, to keep it from being whittled away, from being eradicated, which would then make the point of my being HIV-positive redundant.

There is a lot that is leveled at black people and specifically black males in this country that truly serves to disempower or causes us to be dysfunctional or just causes us not to care about life at all, long before we get to HIV. Every time I get up in the morning I know I'm beating a bunch of odds. But I get up in the morning to do just that: beat the odds.

A friend of mine who works in the various communities here in Philadelphia remarked that when black males come in for HIV counseling, for services, he's most immediately aware not that the men need health care, or T cell counts, or AZT. There are other things that they need, starting with self-esteem, a GED, a raising of the reading comprehension skills, a sense that they are loved and cared for and are somebody recognizable in the society. Then we can treat whatever is raging in their bodies. That's not an uncommon commentary. There was need for me to level my HIV-positive infection.

I'm thirty-five and I've been writing twenty-one years. That's what I mean about the long haul. If I didn't write I probably would have been dead long before coming to this moment. Mine isn't necessarily a classic black male's background coming out of a lower working-class or ghetto experience, but surely there's been enough temptation around various issues along the

way for me to have found myself in situations that could have taken me out of here a lot sooner. That's what I mean about being very clearheaded and understanding HIV in relation to your personal experience and that's what I meant by "leveling it" and understanding that this is one more thing that I'm going to have to contend with. It needs to be put into a context where I'm not disempowered, so that I'm not insane with worry and fraught with a new set of insecurities.

In the controversial essay "Does Your Mama Know about Me?" Hemphill writes that Robert Mapplethorpe "artistically perpetuates racial stereotypes constructed around sexuality and desire." Specifically citing the Mapplethorpe photograph *Man in a Polyester Suit,* Hemphill explains how "Black males are only shown as parts of the anatomy—genitals, chests, buttocks—close up and close cropped to elicit desire."

The real point of my commentary about Mapplethorpe wasn't Mapplethorpe, it was the context in which Mapplethorpe worked, i.e., the lesbian and gay framework. The same framework in which I find myself living and breathing and working. I cited his work symbolically to speak to the issues around race that I felt needed to be spoken to. That's what people, in their zeal to protect basically what some deem a sacred cow, overlooked. Deliberately, or in their haste, the real issues that were being raised about community and how we live with each other—at least how I witnessed it coming through the eighties—were overlooked. I was never inclined to back down from anything that I said because I knew that it wasn't a full-blown critique of Mapplethorpe. It was a critique largely indicting the behavior in the lesbian and gay framework. That's what I stood behind and continue to stand behind. I can tell how closely someone has read the piece by which angle they come from. It's not surprising that the Mapplethorpe symbol is charged, per-

haps even threatens to overwhelm the piece itself and my real intention.

ARNIE ZANE
(choreographer)

We have just completed a new work called *The White Night Riot.* . . . It's to a score by "Blue" Gene Tyranny. It is horrific, because it's all the sounds of the street in San Francisco the night of Dan White's sentencing. [The 1979 riots erupted when White, who had killed Mayor George Moscone and openly gay city supervisor Harvey Milk, was sentenced to only six years.] It's people throwing firebombs and burning all those police cars and storming City Hall and people screaming in the streets, "I'm angry." . . . What with the AIDS epidemic right now, we decided to go back to 1979 and use a piece of sound footage which touches on our subcultural group, gay men.

LARRY KRAMER
(author)

I've made no secret about how I feel. That I don't understand why every gay writer isn't writing about AIDS and I get upset when people use their talents to do other things. I've openly criticized some of our most well-known gay people in the theater, people who should be creating openly gay art, for evading that, particularly in this time of plague. Having started GMHC [Gay Men's Health Crisis] and having co-run it for the first two and a half years and being overwhelmed with the deaths of everyone—that couldn't have helped but form my art, my whole

radicalization, and my complete lack of interest in anything that doesn't have to do with being gay or with AIDS. And I don't understand why every other gay creative soul doesn't feel the same.

With the exception of Paul Monette and me, primarily, and maybe a few of the others in a lesser way, gay writers have been very negligent. We have to use our talents to bring the enormous tragedy of this story to the world. What better way than creating a moving musical or a play or a movie or a ballet?

I know everyone involved in this and I can have dinner with all the top scientists and all the top bureaucrats and all the top people on the Hill. One thing that ACT UP has given me is an enormous amount of political clout. People are available to me. I think some of them are afraid of me, but ironically most of them want to help. The activists have been so successful in commandeering the media that these people come and talk to me off the record and tell me all these horror stories with the hope that somehow I can either get the media to write about them or work behind the scenes to pull a few strings to change things. But it's a very pathetic state of affairs when one of the top scientists in the world comes to me and begs for help. It tells you in a nutshell what we're up against.

PAUL MONETTE
(author)

I've come to understand that to be a writer is a great gift and a matter of some luck. It's not enough to just write book after book after book. The writer has to play a part in the debate of his age, and ours happens to include AIDS. I really wanted to be in the middle of that, and for me that has been very life enhanc-

ing. I'm very moved when I meet kids in college and I see how much more advanced those gay and lesbian people are, how much more evolved than we were able to be in the dread days of the fifties and sixties.

There is much more homoignorance than there is homophobia. That's why we need our artists and our writers so much. There's a great, great middle of the world that longs to understand its gay and lesbian brothers and sisters.

STEVE BROWN
(filmmaker)

I'm more in touch with the political world than I was before. Before, politics was just off on the TV somewhere. I've got this idea to do something in my work, not specifically about AIDS, but about the Constitution, and the Bill of Rights. I'm hesitating about involving AIDS in a major way in my work because I don't want my life to be completely the same as my work. Homosexuality and AIDS are already intertwined. People are going to read AIDS into it anyway.

REZA ABDOH
(playwright/director)

I've become much more aware of action as opposed to passivity. I've become much more interested in active participation in forming your life, your destiny. Before, I was less politically and socially motivated. What sociologists and social critics refer to as this current phenomenon of activism inspired by the AIDS crisis was propelled into the foreground in the past year by rapidly

growing and rampant conservatism and fundamentalism in America. I don't think it's a phenomenon at all. I think it's something that is a direct result of the events of the eighties and the way in which the social context of our lives changed. In a sense it was determined for us, us as artists, as people of color, as homosexuals, as people who do not subscribe to a way of thinking that is white and middle-class. In the past four or five years, activism became a way of taking that course in our own hands and determining the direction that it's going to take—to a certain extent successfully and in other ways unsuccessfully.

DAVID WOJNAROWICZ
(painter)

Despite the glowing reviews, I don't trust a lot about the art world. I never have. I think it's built on tissues of lies. The thing I most care about is that the things I do affect some people or make them feel less alone, give them relief. And I've noticed that's mostly been people who have no money. It's like all my poor friends are the people who are most affected by what I do. And that means a great deal. But it's not something that sustains me. Five minutes later I'm still casting about and still searching. But it's the thing that means the most to me. The art world stuff is temporary, transitory. I won't buy into a system of things that ultimately has the power to throw you off to the side or elevate you to some kind of cult status.

I see this system as doomed, in failure, or in the throes of mortality. We're just watching an entire country seemingly go blindly into it. I think a lot of people suffer as a result of what we're surrounded by and yet don't have any sense of power to shift it or change it or relocate it. Maybe people who make

things, people who do look at it and do examine it and think about it, would have an ability. Sometimes they build themselves an ability to escape it, whether it's fantasy or within the creative act.

JAMIE MCHUGH
(dancer)

I don't think that things will change until we realize that all of us are living with a life-threatening illness. On some level, we all have AIDS, we all have cancer. Look what's happening to the planet. I want us all to wake up. That's the imperative. It's really fascinating because all of a sudden in my private movement practice I'm specializing with people who have life-threatening illnesses. I just stumbled into this thing and it reflects my life. There are all these people with chronic fatigue syndrome, environmental allergies. Where's all this coming from? Who's going to be left? I don't know.

PETER ADAIR
(filmmaker)

At the end of his documentary *Absolutely Positive,* he candidly states: "If they found a cure for AIDS, I would probably get very depressed." Then he adds: "Of course I'd get over it."

Being HIV-positive has given me courage. A lot of people said, "Don't come out about being positive because who the hell is going to give you money to make a movie? They'll assume you're going to drop dead any minute." I always did what I wanted to do and was who I wanted to be and let the chips fall where they may.

MARLON RIGGS
(filmmaker)

Tongues Untied dealt with many of the same issues as Peter Adair's documentary *Absolutely Positive,* but focused on the African American experience, particularly how the gay male experience shapes a very different kind of response to the epidemic, to the virus, and to how one deals individually with it. Too often we assume that there is simply this HIV/AIDS community and all of us are fundamentally alike, or that we should put aside the differences generated by race, sexuality, class, and gender to deal with this monster virus. For me, to be able to deal with the virus, I also have to deal with the differences in how individuals and communities, specifically black communities, have responded to this epidemic. It has devastated us as black people, because we've had so much against us in this country, and here is yet another struggle, another adversary. The tendency for people who have been beleaguered for so long is to simply engage in this massive denial and hope that by ignoring the monster at the door, it will simply go away. And, of course, that hasn't happened. If anything, just the opposite. The monster has continued to consume and to ravage while so many of us pretend that it won't strike us. We simply keep silent and pretend that we're invisible. I know I was like that until I was actually shocked out of complacency by my own kidney failure in 1988, around Christmas.

Knowing that I could die the next day freed me from having to couch what I said in politically correct terms. If you're not going to be here, you don't have to defend yourself. As someone who has been enculturated in good schools, who teaches at a well-known university, who moves through critical, cultural,

intellectual, and academic circles, you learn very quickly, almost subconsciously, how to chameleon-like shape your personality to get by, to move forward with the least obstruction from those who might fear and therefore resist your movement, your advancement, in society. That's part and parcel of what it means to be black, also what it means to some degree to be a woman who is seeking advancement and enfranchisement, to be a person of color, to be gay or a lesbian. To the degree that you move outside those circles in which you are protected from outside hostility and domination, that you try to transform, perhaps, that dominant culture, there are ways in which you aggressively confront dominance. There are other times in which you circumvent it and use it, even use the language and style, the modes of dress, in order to excite the least hostility to you. I was very adept at doing that and still am. But knowing I could die the next day, I said, Why bother? It meant I could say things that I would have been hesitant about saying, things that dealt with self-hatred, black self-hatred, which we don't talk about. We talk about white racism. As African Americans we talk about self-love, "black is beautiful," Afrocentricity, black men loving black men. We seldom talk these days about how self-hatred is not simply a thing of the past, but remains deeply internalized and deeply divisive, psychically, individually, as well as communally.

I talk about that in *Tongues Untied,* about being enamored of whiteness, which is something we don't talk about. Or if we do, it's done in the context of a progression from self-hatred to self-love and the whiteness is not something fraught with ambivalence. It's as though one could simply jettison whiteness and all that that implies from one's life simply by declaring, one day, "I'm black and I'm proud." Or could jettison internalized homophobia by saying one day, "I'm gay and I'm proud." What has made you remains with you, and truthful introspection, for me, acknowledges that and tries to heal from that. But I simply don't

believe that by shifting one's perspective and claiming some part of one's identity, everything else that preceded has been erased.

I knew that would get me into trouble with people who really want a dichotomous political rhetoric: black is good, white is evil; homophobia is something that they experience and not we. Or that the love of whites is intrinsically corrupt and exploitative, that the love of white people is not something that might be felt with ambivalence, meaning that one could actually take pleasure in that love as well as see all the problems that might be associated with it.

I also knew that I might get in trouble with feminists. I was going to use the language of black gay men to affirm our lives, some of which may be interpreted as misogynist and, more often, signifying on women. I was going to use "girlfriend" language, and "Miss Thing" and "bitch," because I wanted to address not only high cultural circles, but also the children on Forty-second Street or on Polk Street or in Watts or in Harlem. Those for whom that language is their chosen form of expression, and for whom there is deep resonance when they hear it. It was not the language that we acknowledge now as being generally free of any taint from all kinds of issues. But I thought, no, this is truth, and there are times when the potential of offending someone has to take a back seat to telling the truth.

I was not going to privilege AIDS and HIV in *Tongues United* just because now that is the hot topic. For obvious reasons, I did not want to make it seem like before HIV or AIDS we didn't exist, or that AIDS is the totality of black gay life, because it is not. We are black, and that has often been as much a determinant, if not more so, of the conditions of our lives in this country as anything else. So I wanted to really look at how HIV is part of a larger picture, a larger mosaic struggle. I know I was critiqued by some who took me to task for not dealing more

frontally with AIDS or HIV, and particularly for not dealing with it in a way that would sympathetically engage straight audiences. It was not for a straight audience, but even so, I did not want to perpetuate that myth that gayness equals AIDS. I think that is the fear, that the only way homosexuality comes up in our public discourse is in the context of stories about AIDS, when in fact we've long had a history that preceded AIDS and we'll have a legacy that far outlives AIDS. It's not to say that AIDS is not critical in that, but there are other areas of identity and identity politics that enmesh with AIDS, and those have to be looked at to deal with the complexities of who we are, and the struggles we're engaged in.

Je Ne Regrette Rien [*No Regrets*] is part of the Fear of Disclosure project, which was begun by Phil Zwickler and David Wojnarowicz. It's the third of a series of videos and films that deals with issues of disclosure within various communities affected by HIV. *No Regrets* deals with the politics of HIV within the African American gay male community. I wanted to address something that I found lacking in a number of other videos that addressed HIV, where one did not get a sense of how race and racial identity and past struggles around race affected one's dealing with HIV; whether a person is of African, Asian, or Hispanic descent, it's as if we're all alike in many ways. It was essential in this project to deal with how our racial identities and paths, personal and historical, shaped how we have been affected by and devastated by this disease. But also how we can begin dealing with it individually as well as communally.

It's told through the stories of five black gay men who are positive, a couple of whom have progressed to full-blown AIDS, and their own struggle around disclosure. The seductions of remaining quiet, invisible, secret. Not simply because of self-hatred, but also because of not wanting to be, as Donald Woods,

a black gay poet, says, "labeled as other and treated as invalid," not wanting to be regarded as sick, a defective human being or even less than human. And there is power in that. There's not simply denial, which is the way many of us typically critique those in our community who are dealing with HIV. Oftentimes there is the full understanding of what HIV means and even the attempt personally to deal with it, but there is the fear that by declaring oneself there might be rejection, not only within the mainstream African American community, but even in the embrace of friends and colleagues and associates, an embrace that regards one as less than what you were.

So it's that level of struggle. And I really wanted to get at the particularities of black life in America today: unbelievable and unspeakable violence that we commit against ourselves, epidemic proportions of drug abuse, poverty, continued discrimination, self-loathing, how those all add to the force of AIDS and its roller coaster ride through our lives, and how we can begin to bring this virus under some control. Not necessarily to eliminate it individually from our bodies, but to not be ridden by it into shame and hysterical denial and rage, that consumptive rage which is beyond control. In the film, each man addresses his own individual struggle, and what you do see in this piece is struggle. It's not a documentary that simply says, "I was positive and self-hating, but now I love myself and I will tell the world."

I really wanted to engage people, even so much so that the documentary shows how some people are not really resolved. It's not as if everybody has made the same trip, which often I find is the dominant narrative of so much documentary making around HIV from our community, in which we ultimately have to show ourselves fully empowered and controlled. You see the people who are still struggling and still dealing with shame and the seductions of silence in different arenas. Perhaps they can tell their mothers; or conversely, like myself, perhaps they can tell

the world through documentaries; but in one-on-one discussions, it's extremely difficult to talk, particularly with someone who is a new acquaintance or potential intimate. So you get those kinds of paradoxes in which those of us who seem completely empowered, utterly rid of shame, nonetheless, in different situations, exemplify that return to "I'm not sure," "Should I say anything?," "Is this the moment?," or "Silence may be better."

Jesse Helms has attacked my work in Congress. Pat Buchanan used *Tongues Untied* to attack George Bush as a patron of smutty, blasphemous art. James Kilpatrick, all these right-wing pundits who have tried to dismantle the NEA or to cripple it so that it will conform to their agenda—they have all used the work. On a certain level, it was phenomenal how a work that is an affirmation of a search for an identity has been skewered to suggest that that kind of search is subversive. And it is, for those who believe in a society premised upon a white, heterosexist, homophobic patriarchy. Of course, it's never defined in such terms. It's called an assault against family values, proper morality.

It's disheartening at times, because no one likes to be painted as a pornographer, or a foulmouthed militant, which is how the right has chosen to portray me. But at the same time, I am aware that this has happened repeatedly throughout our history, and those who have challenged the status quo in a way that touches a visceral chord in the body politic excite all kinds of hysteria. My solace is that those individuals who offered that threat endured. And endurance is in many ways why I'm here and able to speak and do the work that I now do. And my endurance will engender the same kind of resistance for someone else later on.

Even in the moment of those ascerbic and wild-eyed critiques of my work, there is the opportunity to rebut, and in that rebut-

tal, to elevate the discussion beyond name calling so that our identities and issues become part of the public discourse. That never happened before. Even two years ago, people thought of black gay men as some kind of contradiction. Particularly in the majority culture. And now our lives are part of the national agenda and discourse and part of what defines America.

KENNY O'BRIEN
(designer)

Many long-term survivors are artists. They can use the AIDS as stimulation for their art. Often homosexual artists who have overcome family systems pain use that pain to get them into their art. Homosexuals who come out of the closet are already spiritually a step ahead. Early on in life they've been told that something absolutely basic to the core of their being is wrong and won't work. And when the strength of their sexuality finally forces them to come out, then everything else is up for grabs. Racism, the need for war, the belief that black people are dangerous. All the false beliefs that the church and the schools and television and your family want you to harmonize with. When the core belief—that homosexuality won't work—is dismantled, then you can reconsider all the other beliefs and come out with your own view. That's why Christopher Street is the most tolerant block in the world. Nobody judges other people.

When you're an artist, it's amplified. Look at Almaraz. He was terrorized about being gay and used the fear from his life to objectify a vision from his own *bardo* [heart] that he shared with the world. Artists can do that. Something as scary as AIDS can be fuel and inspire. Nobody else can do that. What can you do with the fact that you're dying of AIDS if you're not an artist and can't somehow get it out?

CYRIL COLLARD
(novelist/filmmaker)

I was the first one in France to publicly say I was HIV-positive. I wrote a book about it. I went on TV and spoke about it. Before me, whenever someone died of AIDS, they said it was cancer. And that's obscene. From the moment there's public opinion that needs to be changed, the life of those with the virus depends on our coming out. We'll never have money if public opinion doesn't change radically. It's a social responsibility. That's why I spoke about it. I believe the artist has a responsibility in society. It could be such a strong arm, a strong force, in changing public opinion if the public knew that the stars, the artists they love, have the illness. And that would have a repercussion on the political powers, on research, etc.

The artist must speak out. I asked myself a lot of questions before *Les Nuits Fauves* came out. The first book, *Condamné Amour,* was less clear. It was ambiguous, the illness wasn't named. But in the second book AIDS is named. In the first book it wasn't named because I wasn't yet capable of naming it.

The principal notion behind creation is necessity. And in France, in film and in literature, during the eighties and a little before, we did things that were absolutely not necessary. We didn't challenge ourselves. Necessity grows out of the country's historical events and context. No one in France touched the Algerian War artistically. There were one or two films, that's all. It's probably not just by chance that AIDS arrived now, in this total ideological desert. And I have the impression that therein we can find our necessity, our artistic need.

It's always paradoxical for an artist to look for a need to create, because if it were really a need it would impose itself. But I think

that now we live in an era when necessity no longer imposes itself. There are so many signs, multiplied and multiplied everywhere, that make it hard to find that necessity. One has to really go out and search for it. Artists are finding artistic necessity in AIDS. I'm not saying that AIDS replaces an ideology; it's more an internal movement within certain artists. Unfortunately, there are very few artists now who have the need or the conscience to witness an era and influence the world.

EDMUND WHITE
(novelist)

I was one of the first people in the world, even slightly well known, to identify himself as being HIV-positive. I began to be introduced like that in 1985. I thought it was important since there were literally millions of people who were positive and very few individuals who were willing to talk about that. But the trouble is that American journalists always want a better story. If a person is about to die, that's very interesting. But, if that person lingers on another five or ten years or, worse, never dies, what a nuisance. It's no longer an interesting story. The story on me for *Time* magazine originally was supposed to be about this interesting writer who had come back to live in America. When the editor realized I was positive, it was, "Aha, now we have news," and they ended up using the headline LIVING WITH AIDS.

Same thing again with the *AIDS Quarterly* thing [a PBS show]. The next thing I know, it's been edited down to fifteen minutes and I'm introduced by Peter Jennings as the greatest American gay writer who is dying of AIDS. Questions I had been asked were suddenly put in a context where I was talking about my imminent death.

You just feel sort of burned by the whole media thing. The

truth is, I never ever until now expressed any objections to all this because I still feel it's a step in the right direction. A lot of my friends who have AIDS said the *AIDS Quarterly* thing was the most real and reassuring thing they'd ever seen. You know people. It's not real, it's actually a fake, but that's art for you.

The Sunday *New York Times* asked me to write an article on gay literature as a movement. That what Jewish writers had been to the sixties and seventies, and black women writers had been to the eighties, gay men writers would be to the nineties, the latest wave. I knew from the minute I heard from them it was going to be a big pain in the neck. They asked for endless rewrites, they cut it, they would change everything. But part of my strategy, partly because of the AIDS crisis, has been to try to place gay literature and gay experience on as official a basis as possible. There was something about writing for the *New York Times Magazine,* which in the past wouldn't have interested me at all, that was important to do. Like the *AIDS Quarterly* television program, which was nationwide, and the profile on me for *Time* magazine. I thought in each case it was important to speak out as someone who was HIV-positive in a clear, relaxed, simple way.

Nobody's interested in art anymore. Art is the most despised part of this whole package. To me, art means being true to your personal feelings whether they're politically correct or not, whether they're right-wing or left-wing. Following what you actually think and recording what you actually feel and experience day by day. That means whether it all comes out with a liberal message or not. Art means loving beauty wherever you find it and saying so. Now look at all they tack on Mapplethorpe. Forget the fact that he's dead and isn't around to defend himself; those who defend him, like me, get attacked all the time.

Somebody can't say, "You shouldn't feel that," or "You don't feel that." You either feel it or you don't and everybody knows best what he or she is feeling. And the responsibility of art is to report those feelings. Political correctness stands in the way of that kind of honesty. The political correctness thing is very dangerous. It's really affected my life. Obviously you don't want to be on the side of the enemies of political correctness who are the right wing. In other words, it's a little like the problem that faced people in the fifties when they didn't want to speak out against the excesses of communism, because they didn't want to appear to be sympathizing with fascist regimes. So people said, "Yes, it's true they invaded Hungary, but let's not mention it. Let's not mention the Gulag, because it will be perceived as a comfort to the enemy." But obviously that doesn't work. You have to say the truth, even if it hurts your cause, because what's the good of suppressing anything? And I think that's what an artist's real responsibility is: to say everything. To give a full report of what he thinks, no matter what the political consequences are. I think now there's this new kind of McCarthyism on the left which is very dangerous to artists and can easily inhibit art.

To me one of the problems with all this political correctness is that now there are no people who are even permitted to campaign for the rights of people in other special-interest groups. If you're white you're not allowed to help blacks; if you're black you're not allowed to help whites; if you're a man you're not allowed to help women—it didn't used to be that way. It used to be that people like Sartre or Genet or Simone de Beauvoir were extremely active in embracing the parallel social and political struggles of other oppressed people. Most of the social progress that has occurred in this century has occurred because of such coalitions. You could say that there's a very sinister aspect to the present-day political correctness thing in

that it isolates all these groups and balkanizes them so that each one ends up without any power.

Genet was very active in the Black Panther movement in America and in the Palestinian revolution. It was Genet who talked to Huey Newton and said he should stop calling all the white people he hated "faggots," that it was offensive to gays, and that he should recognize that the women's struggle and the gay struggle were parallel movements. And that led Huey Newton to actually change his point of view and to issue an important proclamation in favor of gay and women's liberation.

In America, gays were left alone to stew in their own juices for a long time. That's why a group like ACT UP is very valuable and necessary in a way that it wasn't really necessary in France. The socialist government here [in France] was elected partly through an early political coalition of gays with other leftist and progressive groups. And because of that political coalition early on, gays later reaped the benefits here of being able to simply go right to the top, state their demands, and get them. Whereas in America, gays never had a coalition with any other group, not even with the feminists. Because all left-wing or progressive groups in America are so pretentious that they don't have allies. Therefore they don't ever get anything done.

ROBERT FARBER
(painter)

My art is now more political; it has more philosophical underpinnings. I feel like I've come by it honestly. These issues have not been intellectual musings on my part, they have been deeply felt crises in my life that I've somehow had to come to grips with. Art that succeeds is by artists that put a piece of themselves into it. Things only work artistically or politically when there is a

deeply felt personal source. The only reason ACT UP has worked up until now is because it was started by gay white men who were all either HIV-positive or they had AIDS and they heard the clock ticking. They wanted to do something that would have a violent impact and make that voice heard. When there's a personal stake involved the politics become sharper and more focused and effective. When it's just intellectual, or philosophical, it doesn't have the cut. I don't have time to bull-shit around. In my art or in my life.

When I did the *Every Ten Minutes* project for Day Without Art, people came up to me and told me how moved they were by the bell. I became really grateful that I had seen this project through, because my intention was to have an impact. I hoped that people might hear this bell and really get a concrete sense that someone had just died of AIDS and go home, open their check-book, and write a bigger check to AmFAR or ACT UP or the PWA Coalition or wherever. I also hoped that it would open their heart more and they would realize that it can't be business as usual: oh yes, there's this little problem. When Day Without Art was over, there was a little bit of me that could now rest if I died tomorrow, because I did what I could and I made a difference on that one day.

This art is becoming much more vivid to me in terms of someone who is going to die from AIDS sooner or later. Years from now, it will help people to understand what it was like. I will have been able to use what resources I had to wake people up. Part of this is to educate and alarm. Now the analogy with the Black Death is even stronger in my mind because, in the Middle Ages, even before the Black Death came along, not every phenomenon of daily life was able to be scientifically explained.

There were all sorts of symbolic, mysterious explanations. People lived within a very small circle of understanding and anything outside of that understanding was attributed to mysterious forces. That's just like HIV.

TRANSFORMATION
OF THE ART FORM

If our life lacks a constant magic it is because we choose to observe our acts and lose ourselves in consideration of their imagined form instead of being impelled by their force.

—*Antonin Artaud*
(author)

Does AIDS push the artist to be more formally experimental? More open to try other mediums and means of expression?

Many artists living with AIDS become more flexible, less self-critical and perfectionistic. However, in the case of photographer Robert Mapplethorpe, the opposite was true. The perfectionistic formality of his work, a veneer in the earlier photographs, engulfed the content of his later photographs and overpowered it, froze it in time and in space. In Mapplethorpe's last pictures, form and content seem immutable. The human body, the flesh he previously scrutinized and idolized in studies of bodybuilders or powerful dancers, has been replaced by stone. Hard, marble statues like Michelangelo's *Dying*

Slave appear in his photographs, looking as strict and impenetrable as his framing.

Mapplethorpe took previous formal concerns to the extreme; others reject them entirely. Testing positive, for filmmaker Marlon Riggs, meant the freedom to allow his art and his life to intersect. It became imperative to include himself in his documentary on black gay men, a move that belied everything he had ever learned about objectivity in journalism. The form of the award-winning *Tongues Untied* is radical in the context of Riggs's other work and the documentary medium.

Is the creative process itself, no matter what form it takes, sometimes more significant than the finished object? For an artist, if the work stops, then does life stop, too?

William Burroughs wrote about art ultimately transcending its medium in *Apocalypse,* the story that was the framework for his collaboration with Keith Haring:

ART. When art leaves the frame and the written word leaves the page—not merely the physical frame and page, but the frames and pages of assigned categories—a basic disruption of reality itself occurs: the literal realization of art. This is a very different direction from Duchamp, Klein and Manzoni, of appropriating everything in sight by signing it or putting it on a pedestal. Instead of appropriating by framing and signing, remove the frames and pedestals, yes, even the signatures. Every dedicated artist attempts the impossible. Success will write APOCALYPSE across the sky. The artist aims for a miracle. The painter wills his pictures to move off the canvas with a separate life, movement outside of the picture, and one rent in the fabric is all it takes for pandemonium to sluice through.

When the picture moves off the canvas, are both art and life more powerful as a result?

MARLON RIGGS
(filmmaker)

Tongues Untied is like a poem in many ways. It's not a linear, straightforward narrative in which I speak essayistically about certain subjects. It makes leaps in the way that verses in a poem take leaps from subject to subject, idea to idea, image to image. To fill in the gap, you have to use your own experience and imagination. The form was liberating.

Before, I felt the need to be measured, like the way I normally talk. I tried to be very clear and deliberate, concise, pointed, to ensure that an audience would get absolutely what I was saying. I tried to reiterate the point in case they missed it, all the things you are taught as a journalist, to appeal to a certain level of intellect, usually fairly low, that does not require too much active engagement in the viewing or reading or listening to of what you are doing.

What was exhilarating with *Tongues Untied* was that I said, "Fuck that." I want people to work. I want people, when watching this documentary, to have to work as hard as I had to work, through all the struggles, to make it to this point. I want them to invest their own lives, their own imaginations and experiences in this story. So they are not passive spectators watching sympathetically, or with some degree of horror at times, this story unfold, but instead see their own lives intrinsically connected to this search for identity, an identity that's affirming and healing.

CYRIL COLLARD
(novelist/filmmaker)

What about transformation of style?

You start to question the efficacy of the work of art, maybe there is less emphasis on the aesthetic. I'm more centered on the core of the work, on the significance of it, the authenticity of it, much more than the formal, aesthetic pursuit. For me, the importance is to show the essence of things. The form, the packaging, is superfluous, unnecessary.

The first book was the least autobiographical and has an extremely experimental form. The second book is very autobiographical and its form is more classic and linear. And I see the third, the journal, as totally autobiographical.

I acted in a couple of films, but I never wanted to be an actor. I still don't. But a lot of the actors I've been meeting for *Les Nuits Fauves* are afraid to play the role, they're afraid of losing their audience if they play a guy who is bisexual and HIV-positive.

What interests me in the character is his lightness and the life. And the actors I've seen are so far from that. They read a script, they see a guy who's bisexual, HIV-positive, and what do they do? They invest all their tools as actors in the idea that it's tragic to be HIV-positive. How do you explain to an actor that he has nothing to change in the way he approaches the role? I don't want gravity in the interpretation. The situation and the story are grave and tragic enough in themselves. A person who's positive is the same as everyone else. That's what I've tried to do from the beginning with the book of *Les Nuits Fauves*. To try to present this thing in as banal a way as possible.

If I played this part, it would be a progression. Part of a whole process where, after writing the book, I talked about it to the

media, and now I'm making the film. If I find no one who can play this ambiguity between life and death, then I'll do it myself.

LARRY KRAMER
(author)

Let's talk about Hollywood. The reason that *The Normal Heart* was a play and not a film is that I knew that no one would ever make it as a film. I felt *The Normal Heart* had to be written very fast and put on very fast, so I made myself write it as a play.

REZA ABDOH
(playwright/director)

I'm working on a film. New ideas are coming because the experience is new. Basically my thoughts are the same. Someone said you're always writing the same book or painting the same painting, but every time it's so radically shifted that you can't possibly say it's the same thing. And in the same way, my film embodies what I'm thinking about, what I'm concerned with—not just my aesthetic but what I'm concerned with in life. What I'm finding out is that the piece is about what's outside, what's inside, and what's outlined and separates the two. How you go from one to the other. How you reshape one in order to enter into the other or vice versa. And that, of course, can denote many things. It can denote the living and the dead. It can denote outside the window and inside the window. It can denote what's on your face as opposed to what's inside it. And I'm finding that the film is depicting more and more that sort of a relationship in its poetics and in its language and in its politics and story.

✧

I'd like to write a novel. A piece that is a narrative, that is long.
I want to try to work with several narratives at once, with some-
thing that is not a visual medium in any way. Where the image
is suppressed. In the past couple of years, I've become more
consumed and seduced by language. And I want to try to de-
seduce myself. For one thing we allow ourselves to be seduced.
The folly that language puts forward is so laden with subterfuge.
You can lay something out in language and the text can destroy
itself, and then what you read becomes something that is com-
pletely alien to the subjective meaning. Text and pleasure have
many things in common, least of which is comfort, and the most
important of which is subterfuge.

ESSEX HEMPHILL
(poet)

We are individually constructing survival grief. With the help
of community, but sometimes very much on our own. Both Joe
[Beam's] and Donald [Mingo's] deaths served as catalysts for
other things to emerge out of me. I hadn't considered writing a
novel, nor had I considered editing an anthology, but the pres-
sure. How do you respond to the death, how do you respond
to the sickness, how do you respond to the love that leaves you,
how do you respond and what do you do and how do you try
to remember what was here as so much disappears? I keep
writing.

That's why it's the long haul, that's why my skills, my talent,
my gift, all of that is even more important now than it's ever
been. It's as important as my being alive. It's the one thing that
I have that can make a difference at least in how I'm personally
approaching this. With my hand, maybe I can remember a Don-

ald or a Joe. I can't be sure that the state's going to remember, or their families are going to really care, or that anyone else will remember, but I remembered and it meant something to me, the love that we had as friends or however that love may have manifested itself.

PETER ADAIR
(filmmaker)

A lot of the gay male survival mechanisms involve humor. You don't see feature films about a gay look at things, with a humorous take. The idea I have for a feature is: It's my funeral. I'm in heaven. It's a third person, it's not me, and I'm commenting on what's going on. The matrix of the film is the memorial service, and as we look at different people there, it flashes back to the character's history, which is totally fictionalized, it's not mine. Probably 80 percent of the film will be flashbacks as narrated by this person and 20 percent will be the service itself. It's a comic *Bridge of San Luis Rey,* or something like that.

We had tried to do a feature that was five separate stories, all intercut, that never came together. They had a relationship, but it wasn't clear that they were related. It's a form that's always interested me, crosscutting seemingly unconnected pieces. What happens is that a whole emerges. I think the feeling of *Absolutely Positive,* and what it says to people, has very much to do with that form. Obviously, it only works because the people we got were terrific. But the power comes from this sense of having all these balls in the air, all these stories sort of in suspension.

I think one thing that happened in writing the narration of *Absolutely Positive* is I discovered a new voice. It's a voice that is very gay, very wry, but truthful at the same time, maybe a little sarcastic. It's a little bit—although I'd like it to be a lot more—

"Fuck you if you can't take a joke." In the writing of the script I've been trying to find that voice and use it more. And the fact that I have a potentially fatal disease has allowed me to do that with a little more courage than I might have otherwise.

KENNY O'BRIEN
(designer)

You begin to say, "What's the worth of what I've created already?" I've changed my process. Now I want to write a book about AIDS and gay men, about how AIDS has taken a lot of very unique lives out of the culture. Without too much of an ego trip, I'm one of them. From the Indian reservations, to the foot of the guru, to the antiwar movement, to organizing the first sit-ins for closing the schools for Martin Luther King Day, to gay prostitutes and leather bars in New York, to running the VIP lounges of the after-hours clubs of the Manhattan rock scene, to recovery and Native American ceremonial life, I've been in a front-row seat of the subculture. And a lot of the gay male population who have died of AIDS have had these unique trips.

I've thought about writing a *Ghost and Mrs. Muir*–type scenario about being greeted in heaven. Well, I've got quite a reception committee, a lot of friends in the last ten years. So we joke. My friend Frankie just died, but we used to laugh that Cookie Mueller will be there with her huge hairdo. We joke about all these friends that are gone and what they're going to be wearing when we come through.

At first, the most therapeutic thing was to just continue with my life. Then I worked on painting the studs and brought all this color into the collection. Then I ran around the garment district with the new collection and reencountered all these sneaky,

spiritually sterile, morally deficient actions. And I thought, I don't need the stress. I just didn't care about it anymore. It wasn't meaningful. I was holding on to this remnant of an idea of creating beauty and putting it on people's backs. Every piece I got on someone's back was a little spiritual job well done. I always thought of it as some pop political work, but I just don't care anymore.

I want to work on the house and the land and the landscaping. It's funny. In my bargaining process with God, it was, "Okay, you can take me out of the world, but just let me finish this space. Let me create a spiritual space." So now the house is done, the trees are cut, you can see the mountains and the stream. The tepees and the sweat lodge are done. Now it's about gardening. And my bargaining has become, "Just let me finish the gardening, God." And since there are four and a half acres, I could garden for thirty-seven years.

I'm painting with flower beds. I was never into flowers. I'm learning about it. It's an entirely new palette. I've already dismantled some of the gardens. When I put them in, I didn't know how big each plant gets. I was working flowers like I work paints. Whenever I do a painting, if I use a certain color in an area I always scatter some of that color elsewhere around the painting. Well, that doesn't work with flowers. It doesn't work in gardens. It's better just to group things together. So the little tidbits of color I'd included around the edge of a bed that echoed the color in the bed, I ended digging up and putting in a bunch of another color. I'm learning about plants and what's going to come back and what won't.

BURTON TAYLOR
(dancer)

I'm renovating this house. I'm just following a vision of what I've always wanted. I've always been interested in spatial relationships. I've always been interested in my surroundings. And I realize that what really runs my life is an aesthetic sense, honoring the beauty that, let's say, ballet is. It follows into my personal life, definitely. So I've got these projects to completely renovate this house. And you see, it exemplifies my will to live. Because the fixtures—the French doors and the windows and the skylight and the Jacuzzi baths—these things take weeks to get. So that's me saying I'm going to live at least those weeks. And I'm already thinking of the spring and having beautiful flowers planted everywhere around the new terrace. So this is sort of what's keeping me alive, in a way.

PHILIP JUSTIN SMITH
(playwright/performer)

I love the idea of writing: You can do it alone; you don't need all those people. You can do it in solitude and silence. But I thought, Why are you writing? First you danced, then you were an actor. Who are you? What have you been through? What do you know? The first things I wrote were about childhood, a lot of animal images, horses from my childhood. Loss, death. Death was a big one. I felt like narrative, like prose, wasn't my voice. As it progressed, what came out was the beginning of a play, which was very different from the play as it is now. In the beginning, it was much more surreal, more theatrical. At one time, the play was a movement piece with dance and monologue.

What finally evolved was the play *Chosen Family,* a very straightforward piece. The main character, Tory, is planning on killing himself in his HIV journey when he feels the checks outweigh the pluses in the quality of his life.

Is Tory me? If you would have asked me that question a month ago I would have said yes, Tory is me. But it's very strange. Tory is making choices now that are not my choices, they are his. So Tory is me, because I'm writing him, but Tory is Tory, a separate person. We don't have the same ideas on some things. Tory is also making decisions about his life—suicide— that I can't even come near. I don't know why Tory's got the pills. I feel that the strength is provided and that you don't need to get it all in tomorrow. This can be a very long journey, the HIV journey, and the power is in this moment now. Right now. But Tory needs to control. He's desperate.

RICK DARNELL
(choreographer/performance artist)

A really close friend who had moved out here from Vermont got sick on Monday and he was dead Friday. It really hit me: What am I doing? At that point I was dancing, doing fluffy pieces and figuring out partnering. And when Craig died, I said, "I've got to get serious about this," so I changed the name of the group to The High Risk Group and changed the focus. It's only recently that I realized how ballsy that was.

PAUL MONETTE
(author)

When I read a book and there is no AIDS in it at all, it's just amazing to me, because AIDS is all around me. I've known hundreds of people who have died of AIDS and that's not even including all the people who have come to me because of reading my books and all their losses. Not mentioning AIDS would be like trying to write a novel that takes place in the mid-forties and not mentioning the war. If you look at my work, in both fiction and poetry from before our "war," I wrote a kind of glib Noel Coward dialogue, a social irony with very convoluted plots like Iris Murdoch. And I don't think I did a bad job of it. Surely my work has shown as dramatic a change as any writer I know.

ROBERT MAPPLETHORPE
(photographer)

This is 1988, it's not 1971 or 1972. Things have changed, times change, the feeling has changed. I can't imagine doing those pictures [the sadomasochistic images] now. It's just a different time now, calmer. I'm talking about AIDS, it's the way people think. The people in those pictures, if they're still alive, would not necessarily want their pictures taken today. I'm older as well. I'm a little calmer in terms of what I want to do. When you get older you step back a little bit. You can't keep taking chances so consistently. It's part of growing old. You think too much as you get older. You're not as willing to take a chance, but that's all right, too. I think I can refine what I've done—which is what I'm doing now, just refining. I can perfect what I've laid the ground-

work for. I'm still doing nudes, but I'm not doing pornographic pictures. I could if I wanted to, but I've done it already.

HERVÉ GUIBERT
(novelist)

I feel like I'm starting over. My first writings were like children's stories, tales. Then another type of writing came from my letters, letters that swelled up and became a journal dedicated to someone. My hope is to arrive at a point where these two voices become one. Writing must come out of itself. For a year I couldn't write *Le Protocole Compassionnel,* which obviously I had in me, because I didn't have the energy to write. Every time I tried to write something it was horribly short, breathless, old, dried-up, constipated, end-of-the-line writing from a very old writer. What I had to tell was so heartrending, pathetic, that I had to write it in an up way. Before writing *Mon Valet et Moi,* I had started another story about characters who actually existed. And I realized that each time I created a line of dialogue, no matter how anodyne, the fact that it hadn't actually been pronounced aloud in reality ruined it. So I just stuck to the truth. It gives the text a very viable coherence, a lot of sureness and freedom at the same time.

ROBERT FARBER
(painter)

Even though I'm now working on three projects—the photographic/video installation, the work on raw canvas, and the panel paintings—I'm more interested in the two newer things, the canvas and the photography. I'm letting the panel paintings

ride along for a while. I feel so filled with ideas and impulses, the work seems to be about me in every way.

BO HUSTON
(novelist)

Some writers are really able to ground things historically. They can just write about Christopher Street in 1979 and the discos and the drugs and things. I'm not like that. So I found it hard to even write the word "AIDS" because it immediately gives the work the context of what time and place. I wanted a more abstract illness, and a lot of the story is just about illness. His friend has this kind of mental illness. Then the more I wrote, the more I realized it's not telling the truth. And I realized I had to say he has AIDS or I'm always going to be short of the truth. I'm not sure how that process works, but you keep working and keep working until the truth comes out.

I thought *Remember Me* was going to be the last book I wrote. And then I thought *The Dream Life* was going to be the last book I wrote. *The Dream Life* came out pretty fast. It came out in these big spurts. Then I worked on it for a long time and kept adding things. And that was another thing in relation to having AIDS. *Remember Me* is very reflective, slow, and everything's constructed, precise. *The Dream Life* is really tough and there are a bunch of unanswered questions and unexplained things. That's what I wanted. I didn't want to spend years laboring over every word again; I just wanted to throw out these images and then rearrange them a little bit.

EDMUND WHITE
(novelist)

A lot of people feel that the earlier work is my best, which I resent. You obviously want to think that your most recent work is your best work, but I understand the difference in taste. French people, especially, like my earlier work better, they don't like confessional writing very much. It was more formal and pure and more frigid, written in a very cold way, which the French like. But I like my more recent work. I think it's more daring, more expressive. My two biggest influences as a writer were Isherwood and Nabokov. Nabokov played a bigger role in the beginning of my career, but the longer I live, the more I respect Isherwood. I like his very simple, direct writing, which I've been moving toward more and more. The Genet biography is not at all fancy; it's written in the most straightforward way.

JAMIE MCHUGH
(dancer)

It wasn't until I started working with Anna Halprin that I discovered there was a whole emotional realm to movement beyond sensation and image. That there's a real feeling behind movement, and the feeling component takes a certain amount of time. Each system in the body has its own movement quality, and the internal organs of the body are associated with the feelings. The movement quality of the organs is very slow just like the glands are very quick. A lot of dance you see is very nervous-system oriented, very gland oriented. Some artists are much more bone oriented, with more sense of direction and space. But the organs, where we feel ourselves, is very slow. I

had never really given myself that kind of movement time. Of really feeling what I was moving.

My lesson was really to learn how to stay still. My diagnosis was giving me a very clear message: listen to my body more and listen to my feelings. Anna's work is intuitive, it's about really listening, noticing how I feel when I'm dancing, how I experience myself. That was very new for me.

I consider myself a dancer in recovery from the world of dance, which I feel, for the most part, is very unhealthy and anti-body and anti-feeling. Since art reflects the culture, it's really no surprise that dance, especially postmodern dance, has become very mechanized and dehumanized. A lot of the dance that I've seen lately has to do with speed, dexterity, and virtuosity, but it doesn't really say a lot. I've seen very little dance lately that involves content, where you really see the dancer in the dance. Most postmodern dance is just a bunch of clones altering the same movement with expressionless faces. And, of course, the face is so much of our personality. We take the face away and what are we left with? A body which becomes objectified. Look at what happens in most ballet companies, with anorectic ballerinas and self-flagellation about being the perfect body type.

In most of my training, I was drawn toward the healing work of dance therapy and the creativity of improvisation. I asked myself where creativity comes into play, and for me, creativity is vitally related to experience and expression of self. It's difficult when your emphasis is outside yourself. Once again, dance reflects the predominant mind-set in this culture. We're a visually based culture, so dance is supposed to look a certain way. There's a visual bias, and when we get very visually oriented, we begin to shape ourselves according to the vision.

I was teaching children and noticing how their movement

expression was so pure and transforming. I wasn't seeing that in any of the dancers I knew; I just saw them doing the same old thing. Dance is a vehicle for transformation, and I wasn't seeing that valued in the art world. I was seeing the value placed on being clever and "creative." It's very interesting how different people define what they mean by creativity. I see a lot of mental creativity, which I really differentiate from feeling creativity, life creativity, and spirit creativity.

SPIRITUALITY

This is in the end the only kind of courage that is required of us: the courage to face the strangest, most unusual, most inexplicable experiences that can meet us. The fact that people have in this sense been cowardly has done infinite harm to life; the experiences that are called "apparitions," the whole so-called "spirit world," death, all these Things that are so closely related to us, have through our daily defensiveness been so entirely pushed out of life that the senses with which we might have been able to grasp them have atrophied.

—*Rainer Maria Rilke*
(poet)

What is the "spirit creativity" that dancer Jamie McHugh spoke about in the previous chapter? Is it having the courage to dive deeply into what Irene Borger called the "collective water"? Is this courage intensified when the artist has a potentially fatal illness like AIDS?

In *The Power of Myth,* Joseph Campbell wrote that "the ultimate word for what cannot be expressed is God." The artist's quest is finding the form to communicate those "God" concepts, to make sense of what cannot be said. This process is spiritual by its amorphous nature; it cannot be specifically explained and generally has little to do with ordinary conscious perception or logic.

Sometimes the creative process begins with a period of questioning;

finding the right questions can unlock the complexities of the unconscious. But if, as Rilke wrote, we have lost our ability to ask the spiritual questions, how do we find the way in? Does an artist living with AIDS have the courage to examine those "Things" that have been "pushed out of life"? Does he have more of an inclination toward spiritual exploration?

Campbell describes myth as "a way of experiencing the world we are living in in a way that will transcend it and allow us to see the divine presence." He states that "the experience of eternity here and now is what life is all about." Is any art coming out of the AIDS crisis able to provide us with that experience? Does the artist living with AIDS experience "eternity here and now" when he is in the process of creating?

Is the courage to create intensified when the artist tests positive? Is the artist more successful now in his attempts to bring order to creative chaos? What can the recurring themes and symbols in this "AIDS art" tell us about spirituality? Can the art coming out of this crisis inspire new levels of compassion?

Does the creative spirit help the artist in his fight to stay alive?

CYRIL COLLARD
(novelist/filmmaker)

Spiritually, AIDS unlocked a lot of ideas. Now I have access, by the people I'm meeting or by the things that I'm reading, to things that I wasn't able to feel before. I don't know for sure if it has to do with the virus, but there's been a proximity to things that aren't necessarily rational, like the way I perceive people or just life developments.

And this manifests itself in my work. In the film *Les Nuits Fauves*, at the end I want the protagonist to find himself in the state I'm in right now, which wasn't the case with the book. I want him to be further along in his personal evolution.

With AIDS there's a clarification of values; one has a certain openness to a higher way of thinking. That doesn't mean that the fear of death and dying makes one function religiously and ask questions like, "What's after this?" I don't think that because I have more of a chance of dying now than someone else, I'm going to say that there's a God or an afterlife, it's not that. But there is an openness.

In the form that it's in right now, the journal doesn't seem to be a spiritual quest. At some point, though, that's going to happen because I'm surely going to come in contact with people who are going to lead me in that direction. I don't think I'm capable yet of writing a book about someone in our day and age, in a city, with AIDS, looking for something spiritual. It's a very interesting idea but I'm not quite sure how to go about telling that story yet.

I seem to have a spiritual tendency that I certainly didn't have before. I have much more personal curiosity about death. Before, certain themes that fall into a spiritual domain didn't touch me or interest me. I think it also has to do with something one gives off oneself, something like an aura. It's very clear to me: you always see yourself in the look of others, you try to understand yourself by the way others look at you. I know that the way others look at me has completely changed over the past one or two years. And strangely, it hasn't changed in the way one would expect. A priori, you'd think people would look at you like you were already dead. But, in fact, it's not at all that. They look at me like someone who's much more alive now than before. And I know that what I give off is something much more serene, something between maturity and serenity. There's been an acceleration into adulthood, the end of adolescence. After all,

we're in a society where adolescence is longer and longer. We stay adolescents for a longer time now. Maybe the menace of the illness speeds up this passage into adulthood.

HERVÉ GUIBERT
(novelist)

People stop me in the street. They tell me their troubles. That bothered me. And certain words kept appearing in the letters I received: "saintly," "you're a saint," "Saint Sebastian." I thought about it and suddenly I realized that *Le Protocole Compassionnel* has a Christian structure. I wasn't at all conscious of that when I wrote it. There are tests like the Stations of the Cross: the basement of the hospital, the bronchoscopy. Then there are all those scenes, where I'm clinging to the neck of the masseur, hanging around the neck of the doctor, that are in the form of Pietàs. And then, at the end, there's a pseudoresurrection. But the same way that I'd like to physically rid myself of AIDS, I'd like to rid my books of it as well.

REZA ABDOH
(playwright/director)

AIDS has created a landscape in which the body and the spirit and the politic of the body and the spirit can be examined, reshaped, restructured, destroyed, and re-formed. I think it's important for us as a people who are not embracing the status quo to discover our own road to what you might want to call redemption or salvation. It has nothing whatsoever to do with the Judeo-Christian idea of salvation or redemption. It has to do with a certain kind of peace that you find within yourself and

you transmit, hopefully, through a generous act to your community. I think the queer community has managed to come to some kind of an understanding of that need for discovery.

It comes into the work first and foremost through my conscious and subconscious channels. It works itself through in subliminal ways. Everything I do in some way deals with the notion of restructure, restructuring of something that has been destroyed—something that has been either intentionally destroyed or destroyed by means beyond your power. Death and redemption and ecstasy and structures of family which are laden with unexamined concepts. It's a way of looking at these things and thinking, How do we reshape them? How do we look at them again? How do we create a way of accepting who we are in our own image rather than in someone else's? That's something that my work deals with over and over. And the struggle with faith, blind faith. The struggle with the surrender to faith that I have personally. Kind of an oppressive antihumanism that takes over the consciousness when you're dealing with certain issues. Or when you're looking at the kind of life that is perpetuating those ideas.

The notion of God as put forward by Judeo-Christianity or Islam and other religions that are basically factories, institutions—the notion of God, of the Creator, the Jehovah, the one who creates and destroys, the one who punishes and rewards, is something that we grow up with and is a reflection of the patriarchal model. In a sense it justifies the patriarchal model through its spiritual jingoism. And that sort of spiritual jingoism is something that I critique a lot and attack a lot in my work. Constantly. Because not only does it reflect the hypocrisy and the outright evil of certain institutions and certain institutional thinking, but it also goes to the heart of the models that we are taught, conditioned and forced to accept and believe in. Like the

family. Or the working model, the model of consumerism, the model of the media, and so forth.

KENNY O'BRIEN
(designer)

I've had this great faith in God; I've always had it. Only God exists. The world is a psychedelic *Sesame Street* of the soul which we just pass through, where we experience all these gains and losses. I just think it's preparatory, that God has prepared something so intense for human beings, something that we can't even imagine. For all of my running away from God and dallying with nonsense, I always came back to the feeling that the world was on one level perfect and on one level senseless.

I've had this spiritual smorgasbord kind of life, and when I came up here to Woodstock I said to myself, "You have AIDS. You don't know how long you're going to be in the world. Do you have a religious life or not? Are you going to continue the spiritual shopping spree or are you going to commit?" I think all paths lead to what the Indians call "grandfather." If I have a religion, it's Sundance. So I made a commitment after my diagnosis, and I've been in the sweat lodge every week since.

Although I knew all those years that I was HIV-positive, when you finally test and it's confirmed, it's something else. I went into ceremony. Every night I went down to the tepee and I filled my pipe with Red Willow Bark and I asked the earth, "Please help me, I don't want to die." I went through two weeks of crying every night. I was very sad. And then, for some reason, I snapped out of it and I kept going on. I kept working, clearing the trees, building the house. It was fabulous.

❖

Things like colors, you notice them more. When you lose weight that severely and your appearance changes so drastically, that spurs on the awareness that you don't have long to be in the world. I don't know if it's biochemical; I don't think so. I think it's the spiritual enthusiasm for sussing out of the world as much as you can while you have the time. The Indians say you can always take a step on the path of beauty. Look for the trail of beauty when you're in trouble and suffering. You can find it in a hummingbird or in a song or in a cloud; look around for an opening. A color that will strike you. The crickets. I have a lot of spiritual tricks to get out of obsessing on my pain.

You're aware of the details, things you used to miss. The world has become much more vivid. Very van Gogh sometimes. Like, "Whoa, look at that leaf, it's really a leaf." A psychedelic perception. The world is fabulous. A day on this planet is an enormous gift. You really get it when you think your days are definitely numbered.

BURTON TAYLOR
(dancer)

I don't run this show. I never have, even though I thought I had. Many times onstage I thought I ran the show, you know? I wanted to be in control of the lights, and what angles the audience was seeing, and all that stuff. But, of course, "God steers, I row," which is an expression I like an awful lot. And that's one of the very strong basic things for me to learn in my life. Especially since dancing is so regimented and I can be fooled so easily into thinking I'm sort of doing it. It's so important to remember I'm not doing it. It's this wonderful loving force working through me. . . . And the best performances are when I get out of the way.

TIM WENGERD
(dancer)

Wait a minute. I got into this because I believed the art of dancing was something that brought people close to the gods. It was not only a way for the dancer to do it, but also for him to bring the audience there through the beauty of what he is doing and the physicality of it. I really think the body is divine, wonderful, incredible. While we're alive and when we're healthy, it is really an astonishing instrument. There's some great driving spiritual thing inside each one of us.

And I know when I see someone like Merrill Ashley go whipping off those little businesses that she does, or Kyra Nichols, God, I look at those women and I just say, "Oh, you women, I hope you realize how close to being in real central harmony with everything you are and what the earth is and what the universe is." And I think they do.

TORY DENT
(poet)

If I ever believed in a god, I definitely don't anymore, only as a sort of Job-like hateful asshole. Yet replacing a belief in a god or an afterlife is a desire to accept life as it is and people as they are.

There's a different kind of spirituality that is much more pragmatic and therefore more directly comforting. I live, I die, I become horse manure. That's life. To me that's a comforting, cold-water-in-the-face realization that I find refreshing. I feel a whole spectrum of things about spirituality. In the beginning, in

the poem "Jade," I referred to a vision quest. I felt that what I've been through with my body has been a guiding light to understanding things about life and myself. And who knows what's behind it? If it's a higher force or just coincidence. I learned many things from that concept of vision quest.

There's also the idea of an animal totem. Every year I have an idea in my mind of an animal totem. The first year it was the grizzly bear. I referred to it in "Jade" as becoming like a mother to myself, taking care of my little immune system and me. This indomitable parent just ready to rip out the throat of anyone who gets in my way and tries to harm and stress me. The second year it was the sea gull, in the sense of being absolutely invincible. I could digest anything, eat nuts and bolts and nothing could destroy me. Maybe this year it is a phoenix, able to transcend any adversity that comes my way. These are really just little figments of my imagination to guide me. I don't believe in any direct correlation or a higher force. I see it from a very Freudian point of view, as a wish fulfillment for a father or for a parental figure, or for there to be some larger, omniscient breath that will feed us. But I think that has to come from me, from my own strength.

I don't think that comes out of bitterness; I think that comes out of acceptance. Higher degrees—or I say lower degrees—of acceptance. Just trying to accept life as it is. And, for me, the way to accept it most completely is to entertain the possibility that this may be all there is.

If this is all there is, I don't feel a need to transform it. I don't think I've become more spiritual. I've gone in the other direction, toward a very sobering feeling about the beauty in reality and the beauty in what is my life. If I can accept that, it's a way to gain a lot of strength, rather than believing in some big megaplan behind it all. If I do start believing in that, it quickly

dismantles itself by another insight anyway. To me, reincarnation is a perfect fairy-tale recycling system. It's sweet, it's an adorable concept, and if it can help people, great. But I don't really believe in the continuum of my soul.

ARNIE ZANE
(choreographer)

It's really fortunate that I've made four dances this year. I made this dance called *The Gift/No God Logic.* I called it that because—I always sort of try to avoid the question when people try to bring it up—I felt it was the last gift I was giving, that it was the last dance I was making. And I don't believe in God. There is no God logic. I mean, thirty thousand people dead from this disease, all from my subcultural group. If there is a God in any form, I don't understand it, and I don't accept him or her or this being or spirit.

LARRY KRAMER
(author)

I don't believe in God. I find it incomprehensible that anyone could believe in God after what we've been through. I have learned in every possible way the horrible things man can visit upon his fellow man. I'm just overwhelmed by it all. There is not a good word to be said about anybody's behavior in this whole mess. That's a line from *The Normal Heart,* and that's true more so now than ever. When I first got involved there were forty-one cases. They're now projecting forty million and that's just in a decade. All of this could have been prevented. That it's been allowed to go from forty-one people to forty million is a yardstick of how hateful I think humankind can be.

ROBERT FARBER
(painter)

Even though I don't put any time into figuring out God or the bigger picture anymore, I don't see how one can consider one's mortality without feeling an element of mystery. It's awesome, the whole gig from beginning to end. But rather than a spirituality, I experience it as a sense of mystery. It's one of the remnants from reading the existentialists, like Sartre and Camus. I've also been reading Nietzsche lately. I was looking for help on how to continue. I was looking for help. And I found myself clinging to these writers and trying to find out how they managed.

STEVE BROWN
(filmmaker)

I wrote this script called *The Reverend and Penny Jean*. It's southern Americana. I used to live in North Carolina and go to the PTL Club—you know, Tammy Bakker and Jim—to get ideas about what these people were like. I began to write this in 1984, and it is about a girl who can bring people back from the dead.

When I put this in the computer lately, along with another script I wrote, I thought: Death, blood, transcendence—this is about AIDS. When you think how anti-Catholic I am and what my whole attitude toward life is, it was very heavy for me to write a story about somebody who is brought back from the dead and has a hallucination that she is screwing Jesus Christ. I remember writing that out as a story; when I wrote, "She looks up and sees Jesus," I remember stopping and shaking and saying, I can't believe that I'm writing this. It's all about AIDS.

✧

I've always been very interested in morality as a theme, in the idea of good and evil. What's good to one is evil to another. There has got to be some morality associated with spirituality. I don't feel much more spiritual now. I think that I've always had it floating around in me, but I don't get down and pray all the time. I never did.

BO HUSTON
(novelist)

The big mystery of the illness is why some people suffer and why some people are saved. It's totally mysterious. I've found myself, especially over the last few years, writing stories in which the characters resort to prayer in some way. And sometimes that's a comical kind of thing. I find it fascinating how people have personal relationships with God; I find that a really enviable thing. Sometimes I'm cynical about it, because I wasn't raised with that. My mother was an atheist Jew and my father was just an atheist. I've grown up with people who don't believe in God, but they really do. And that's how I consider myself: an atheist who believes in God. That contradiction is always there.

DAVID WOJNAROWICZ
(painter)

All my life I felt angry toward my experiences with the Catholic Church, the tremendous amount of bullshit I watched my father, or neighbors, participate in. I feel like organized religion is about nothing but mass hypnosis, control, and things like that. But always, all my life, even as a kid, I always left it open for myself. I write things down in case I

might want to look into it at some point. But I don't get too encouraged about spiritual beliefs or longings. It's like I don't buy it. It's not appropriate for me.

ROBERT MAPPLETHORPE
(photographer)

One of his last photographs is a picture of a fallen Icarus, a neoclassical sculpture from his own collection, juxtaposed with a perfect square of divine white light.

> I was a Catholic boy. I went to church every Sunday. The way I arrange things is very Catholic. It's always been that way when I put things together. Very symmetrical.

RICK DARNELL
(choreographer/performance artist)

In the painted backdrops for *Brides of Frankenstein,* a dance he created for The High Risk Group, a junky priest with exposed genitals holds a syringe in one hand and a rosary in the other. A cherub throws flowers on the priest while another cherub is beaten to death by a riot cop. There are angels and crosses and a tattered American flag with skulls instead of stars.

> In the *Brides of Frankenstein* backdrops, there's coding about the church. I have a big distrust of the church, especially the Catholic Church. They're killing the world.
>
> AIDS brought spirituality to our community. It brought people together. Death does that. With AIDS, you love your friends more, your friends are more dear to you. It's brought realness. A lot of people with AIDS turn to all these forms of spirituality. If I was on my deathbed, I'd call for a Catholic priest just so I could spit in his face one last time before I died.

DEATH
AND LOSS

I have run to the very end of this diluvian night.

—*René Char*
(poet)

How does the artist living with AIDS explore death in his work? Is death sometimes the inspiration behind the work, or is art a place to escape from these thoughts?

Art is one of the few areas in our culture where we deal with death at all. Western civilization has done its best to push death out of its thoughts. As mentioned in the previous chapter's epigraph, we may have reached the point of no longer having adequate faculties to think about it.

The AIDS crisis, however, has brought many of us to a place where we cannot *not* think about death. As playwright Scott McPherson, who is HIV-positive, stated, "When dying becomes a way of life, the meaning of the word blurs." With people dying all around us, death is not easily ignored.

"We're a death-denying culture," stated art critic and historian Robert Atkins. "I think that because of that, living in these circumstances is just as hard as dying." Does the art of the AIDS crisis explain what it is like to live with a "time bomb"? Does having a creative outlet to work out the fears around death help the artist who has HIV or AIDS cope with living?

When a cataclysmic event like a war or a plague shakes up everyday reality, people are forced to face death. This shift is often evident in the art of the era. According to Barbara Tuchman, who chronicled the Black Death in her historical novel, *A Distant Mirror: The Calamitous 14th Century*, "a strange personification of Death emerged from the plague years on the painted walls of the Camposanto in Pisa." Throughout Italy, themes of death and devastation appeared in church frescoes and "marked the start of a pervasive presence of Death in art, not yet the cult it was to become by the end of the century, but its beginning."

During the Black Death, death also appeared as a significant theme in other art forms, like literature, theater, and dance. The notorious *danse macabre* was a direct result of ongoing plague and emerged "as a street performance to illustrate sermons on the submission of all alike to Death the Leveler."

When a viewer or reader comes in contact with art about death or disaster, it is usually at a safe distance. Whatever thoughts the artist communicates are mediated by form. The subject is also often couched in symbolism. Ironically, in a lot of the art coming out of the AIDS crisis, death and AIDS are directly named and represented.

"AIDS is a great opportunity and challenge to talk about pressing social issues in a direct way," explained Atkins. "I think there are enormous opportunities for a discourse here."

Is the public fearless enough to take part in the discussion? Will the art being made by artists living with AIDS push more people to grapple with such formidable subjects?

In the drugs–sex–rock-'n'-roll culture of the seventies, death and destruction were celebrated. By the nineties, though, with AIDS personally touching a large segment of that subculture, death had lost its attraction. As author

Dennis Cooper wrote in the catalog for *Against Nature,* an iconoclastic art exhibition that in 1988 showcased some of the first art to come out of the AIDS crisis, "AIDS ruined death." It was hard to continue to view death in abstract or romantic terms.

"In the early eighties, we were all into the glamorization of self-destruction, which wore thin after people started really dying around us," stated photographer Nan Goldin, who documented the subculture from within. "It seemed really self-indulgent to be killing ourselves when our friends were actually dying. And it seemed imperative that we be present in the world to help each other. I don't embrace death in the same way anymore. I don't flirt with it. Life has become much more precious to me. I'm less close to death; I embrace it less. I'm not as scared of it, either."

Does a direct examination of death make the artist living with AIDS less fearful of it?

DAVID WOJNAROWICZ
(painter)

How I view what I make is not incredibly different from how I always viewed what I made because all my life I felt like I was just a number of steps beyond death. And a lot of that had to do with what I grew up in and living on the streets. It took ten years getting off the streets to believe that I was fully off the streets. I never completely lost the fear that that could happen to me again, and that was such a brutal experience.

I don't particularly accept the possibility of my death, but also it's right in my face. There's enough evidence around me so that I see what's happening, what's happened to a lot of people I know, the deaths and illnesses I have witnessed, the people I've taken care of at one point or another. So death is very real to me. I'm thinking that maybe the blankness, the sense of being a

stranger inside my own body is a result of that intensity, that increased sense of mortality.

I still have certain urges to work with images or materials or writing. I just feel like I hit a point where I'm not so sure that anything I'm looking for is outside of myself. Whether it's landscape, people, whatever, I feel like I've hit a moment where I just feel an emptiness with regard to everything and that whatever I'm looking for is internal or in my head. I have no idea how long that's going to last or if that's going to affect whether I care to work again, whether I care to make things again. I'm sort of riding it. I feel fairly comfortable at this point with it.

My entire life I survived a whole range of events that were pretty brutal events and I always had this ability, this seed of something that I hate to call hope. It was like a pocket I could drift in to survive things. It was something that had fantasy, something that had a sense of positiveness or hope. All those kinds of emotions that help you move forward, help you make sense of the world, help you travel certain roads. And I feel like that abruptly ended a number of months ago. I don't think it's losing hope. I think it's the reality of the possibility of my death—whether it's in a year or two years or whatever.

I abstract the disease I have in the same way you abstract death. Sometimes I don't think about this disease for hours. This process lets me get work done, and work gives me life or at least makes sense of living for short periods of time.

There've been radical alterations in terms of perception and sensitivity from the terrific amount of loss around me and from my own increased mortality. It's been an ongoing process. It shifts and changes constantly. Sometimes I can think about it

and maybe write things that, on a certain level, are poetic and have a sadness to them, and then I can write things that deal with other emotions, like anger. The way I see the world—at times it just feels laughable. It's both frightening and laughable, the construction of the society. I can never get away from what I'm living in. I can never ignore what I'm living in and what I existed in for thirty-six years. But those perceptions or sensations get heightened and they shift and they change. It's these very subtle and gradual changes of how I view things. I may be more tolerant of certain things than I've ever been in my life. I may see people's humanity a lot more than I ever could. I also don't put up with very much bullshit from people.

ESSEX HEMPHILL
(poet)

When you talk about death, one of the things that terrorized me or terrified me when I came out and was in the life, from the mid-seventies through the eighties, was murder in the gay community. That's what terrified me. I never considered that there would be some virus moving among us that would wreak the kind of havoc and destruction that we've seen AIDS wreak. Nor did I expect, though logical reasoning should have made me understand, that this society would react so slowly and ignorantly to AIDS. But in any event, the catalyst for *Standing in the Gap*, the novel I just finished, was not my HIV status or HIV as I've witnessed it moving in the communities around me and in my personal life. It was the murder of a friend who was found in his closet, which is just incredibly symbolic. He was the catalyst, Donald Mingo. That's one of the old ways of dying. "Old" based on what I had witnessed within a gay and lesbian framework. *Cruising* was one of those films that I saw that left

an impression on me that I still have to shake when it comes to strangers and meeting people for the first time. There were certain risks in terms of being gay and what that meant in relation to death at one point in the gay and lesbian community versus what being gay and that relation to death means now.

None of us were prepared for the call about Donald. The phone rings and you expect that it's someone you know who's been in the hospital. You have a certain set of reactions that have already been conditioned. The novel's not about Donald. The novel looks at HIV specifically in a black context and around the tension between the black church versus HIV/AIDS, lesbian and gay issues. I haven't seen anything yet dealing with that. That's how I worked my grieving for Donald.

TIM WENGERD
(dancer)

Well, it is a bit of a tough cookie to look the truth in the face. And in order to do Martha Graham's work well, you've got to do it. You have to really look at death because death is contained in every moment of dancing, along with life.

Martha was sitting there and she had her eyes closed. And I did get this absolutely palpable sensation that she was thinking of all those sets and all those things she had created and how difficult it was going to be to leave it. One day she came in and she looked at me and said, "Oh, Tim. Life is such a beautiful thing." She said, "Why do they make us die?" And I thought, Well, Martha, that's the contraction and that's what we have to do. And yet I didn't say it.

One day I came in and started having my colitis. And I was feeling just awful. . . . And I didn't know what was happening.

All I knew was that something was not working right. I came in and she said something like—"How are you today?"—and I said, "I'd rather be dead." And she said, "Don't you ever say that in this studio again."

I mean she got really upset because she was fighting so hard to stay alive. And I don't think she realized how awful I felt there toward the end. . . . Here I was having these physical problems. And the doctors were saying, "You've had a horrible virus, you've had a very strong virus, but you'll get over it." And I just wasn't getting over it.

PAUL MONETTE
(author)

There was something very special to me about writing *Halfway There*. It was all written during the time I was with Steve Kolzak and I happened to finish it four or five weeks before he died. Somehow, it's a joyous book. It's not as steeped in death as what I'd been writing. It manages to go with the family that's created and there is this person taking another chance at love. There's no way I could write that now.

I love the line from *Halfway There:* "day to day, I'm not a dying man."

AIDS becomes a challenge to that kind of statement. Sometimes I can achieve it for half a day at a time, or a couple of hours at a time. Sometimes I can achieve it for days on end. What's curious about me is that, because of my willingness and longing to be part of a political debate, I was in a position, as a seropositive man, to be the AIDS poster child for a number of years. And full-blown AIDS is a really different ball game. It's much more complicated territory and I haven't yet found a way to talk about it. I've come pretty close to the fire in talking about what it is you lose, what wisdom you get, how you go forward. One of the

challenges of AIDS, in the midst of all the doctors and treatments, is to maintain the sense of self, and honor it and live it.

I'm not sure where the art comes through at that point. I'm very moved when I think of how passionately Mapplethorpe worked, or Reza Abdoh works, in the midst of it. I think of Keith Haring as drawing until the moment he dropped dead. I don't know whether that's in me or not.

KEITH HARING
(painter)

Part of the reason that I'm not having trouble facing the reality of death is that it's not a limitation, in a way. It could have happened anytime, and it is going to happen sometime. If you live your life according to that, death is irrelevant. Everything I'm doing right now is exactly what I want to do.

COOKIE MUELLER
(writer/actress)

In 1982, my best friend died of AIDS. Since then there have been so many more friends I've lost. We all have. Through all of this I have come to realize that the most painful tragedy concerning AIDS death has to do with something much larger than the loss of human life itself. There is a deepening horror more grand than the world is yet aware of. To see it we have to watch closely who is being stolen from us. Perhaps there is no hope left for the whole of humankind, not because of the nature of the epidemic but the nature of those it strikes. . . . All of those friends were connected to the arts. Time and history have proven that the sensitive souls among us have always been more vulnerable.

CYRIL COLLARD
(novelist/filmmaker)

The proximity to death means being more alive, more in life. You become more human. The menace of the illness and death has made me feel like I belong more to the world. As if life is not something that can be summed up by one's own life but by life in general. I was someone who, from the get-go, functioned very egocentrically, like a lot of creative people, I suppose. I don't want to say that I've become altruistic; it's not that. I'm still very suspicious of altruism. But there has been a change.

Before I tested positive, death was about losing oneself relative to the fact that I have a lot to do here. After I tested, I felt the loss of the self as something much less dramatic.

In 1983, I made my first film, a short, *Grand Huit*. The film ended with a quotation on the screen from one of Fassbinder's first films: "Love is colder than death." The theme of the film was the tragic impossibility of love inside society.

Something strikes me now in that film—the conception of death as something completely theatrical. The way it's directed is very unreal, very external. The way I chose to portray it is as if writing about death, or filming death, didn't engage me at all. The vision is very outside myself. And little by little, in my evolution, this has changed.

For example, the second film I made, *Alger la Blanche*, was in 1985. It was right before I had my first test, but I was absolutely sure I had the virus. In that film, death is already different. The relationship with reality is more down-to-earth, more raw and realistic. And in my new film, *Les Nuits Fauves*, there won't be any death at all. It's as if the more one advances toward death, the harder it is to represent it exactly. In *Les Nuits Fauves* there's

a happy ending, a double happy ending. First of all, for the girl because she's not infected, and for him because, in a certain way, he says he feels alive. There's a familiarity with death that I have now that makes it no longer possible to represent it as if I'm outside of it. It's like a very close friend; we don't take the same liberties in portraying him as we would in portraying a policeman or a politician we see from afar.

It's pretty striking: in the first film I killed someone very easily, in the second it was harder, and now, in the third, there's no death at all. Since it's so hard to represent it in all its complexity, I'm better off not having anyone die. The proximity to death makes one shier about representing it.

Now if I killed someone in a film I'd ask myself incredible questions. I couldn't represent it like someone going out to buy a loaf of bread at the bakery. I could no longer present it as something anecdotal. It would have to have a very, very important tie to the story, to the reality of the story.

HERVÉ GUIBERT
(novelist)

Maybe if there hadn't been AIDS, I would have been dead today, because I was so attracted by death. I always did things very impatiently, with the feeling that there wasn't a lot of time. It's true that death is also a formidable narrative incentive. To use the protagonist's menace of death by a virus as a point of departure for a novel is as good a narrative theme as money or a trip.

The first line of *La Mort Propagande* is a very violent, adolescent sentence. It wasn't even the real first line. The book is going to be rereleased with the real beginning, which was even stranger and more foreboding. I was very conscious of death during

the period when I wrote that, even more conscious than now. Today death seems so natural to me. I no longer have the fascination and the terror of death that I had then. I have the impression that death comes at the right moment, but that's certainly false.

PETER ADAIR
(filmmaker)

We all try our best during our life not to think about death, so when you do, you have a different take on things. In order to deal with this situation consciously, it has to become internalized. It has to become who you are. After you hear the news, unless you're in denial you can't walk around the same. It's genuinely threatening.

I think making the feature represents the ultimate in control-freakism. It's designing my death through fiction. The main character is talking from heaven as they're throwing the ashes.

BO HUSTON
(novelist)

Right now my focus about writing and having AIDS is not so much the experience of illness and decay but the concept of healing, because that's what I'm focused on. So in a way it's not about AIDS. I'm not writing a book about all these people who get cured of AIDS, but I'm writing about rejuvenation and those expectations of illness and death.

I'm not prepared to live. I've been preparing to get sick and die.

YURII CACHERO
(dancer)

I really do have to work at living my life from a positive place, you know. I need to remind myself from time to time that the way I think, that my thought processes, can sometimes rule the way that I perceive myself as a person with HIV disease; that the words I use to describe how I go about living my life as a person with HIV disease influence a particular mind-set. And the mind-set I want to nurture is one of living. It's not that I'm saying I don't want to die. Of course I don't want to die. But what I'm working to do is extend my experience in living. All I'm saying is that while I'm physically well and healthy and able to breathe and function mentally and physically, there's no reason for me to stop living. There's no reason for me to think I have to give up some of the things that are very important and vital to me in my life. And dancing certainly is one of them.

REZA ABDOH
(playwright/director)

His latest play, *Bogeyman,* has as one of its themes the disintegration of the body. Although AIDS is not named, it is certainly evoked.

I don't connect deterioration of the body with shock. It might arouse compassion or pity in people. It might arouse revulsion or self-pity, fear of what happens if *they* look that way. It's a tragic way of responding to decay, which has nothing whatsoever to do with a genuine response. It has everything to do with: "I will feel this way because after I have felt this way I can put that feeling away and move on." I think a lot of people's responses when it comes to decay, deterioration, destruction are

calculated. I don't think they're genuine most of the time. Basically people are so accustomed to seeing, witnessing, hearing about atrocity that decay and destruction and deterioration of the body or mind are not things that are going to affect them on a level beyond how they connect to a thirty-second item about some impoverished country on the local news. The mediated information has calcified people's imaginations and people's reflexes and responses.

I think death exists in the fourth dimension. Not as a reality or a concept that ends or brings to an end, but as something that provides the opportunity for regeneration. That might sound inanely Christian or godly. I don't mean it to. But within the framework of destruction and construction—within the framework of that dialectic where things are destroyed, ideas are destroyed, lives are destroyed or self-destroyed—within that framework, ideas and people and thoughts and objects are reconstructed. Within that dialectic, even in the fourth dimension—beyond time, beyond space—there is the need for that kind of a regeneration. Otherwise you are in a state of stasis. And that's not what the fourth dimension is about. It's totally the opposite.

EDMUND WHITE
(novelist)

For me, one of the biggest problems psychologically in the eighties was that it was very hard for me to separate the effects of just aging naturally and the effects of feeling ill, isolated, and doomed that are connected with HIV. I couldn't figure out which was which.

There is a lot about aging and death in *Caracole,* especially in

the character of Mateo, who is partly based on me and partly based on David Cowstone, a friend of mine who was in fact ill and who died about the time the book came out. I think that though there's nothing about AIDS, there's a lot about facing middle age, facing aging and dying, in the book. Mateo is an uncle and he's very aware of his young nephew next to him, who represents all this élan that he feels is becoming extinguished in himself. So in some very remote way, you can say it's a reflection on that premature sense of aging that people have when they're HIV-positive.

DEMIAN ACQUAVELLA
(dancer)

I couldn't walk, so Bill [T. Jones] carried me onstage at the Joyce Theater and I just did arm gestures, which I'm very good at—expressing myself through my whole body.

ARNIE ZANE
(choreographer)

We couldn't do this forever. We couldn't. There reached a point where— We knew Daniel Nagrin. He'd always been sort of a hero to us. We said to ourselves, you know, "I don't want to . . ."—and this is not a put-down of Daniel, but—"I don't want to be old like Daniel. I don't want to be without a group that I can make dances on. I don't want to be an older body that's falling apart." And here I have a young body that is degenerating. This is a—a bitch—but one never knows in life how it's going to go.

PHILIP JUSTIN SMITH
(playwright/performer)

Even though I courted death with my life-style, it was the fear of death that kept me from reaching further creatively. Since I became HIV-positive, I've made a conscious effort to go toward the darkness. It hasn't freed me from death, it's made death very present. But what I am free of is the fear of death. For the most part, it's brought this sense of rich living.

You know how the gay community was always at the forefront? Of fashion, or design? Well, in my heart, I think that today's forefront is exploring the edge. The edge of life and death. We're the agents exploring mortality and the eternal. When we do the AIDS Project L.A. writing workshop readings, it reverberates in that way. Our trip is AIDS and HIV-positive, but it's really everybody's. We all have AIDS. Death is our companion and life is our companion.

JAMIE MCHUGH
(dancer)

I used to feel pretty immortal. I didn't really start dancing until I was twenty-one, and discovering movement and the body at that age was incredible. My twenties were about moving a lot and generating more energy in my body. It was exciting. I had been a mental kid and teenager from the time I was fourteen, so my twenties were about discovering the energy of my adolescence. I certainly wasn't dealing with mortality. I was into a Peter Pan syndrome, feeling like I was going to be young forever. It's not like I spend an inordinate

amount of time now thinking about dying. Death feels re-
mote, and at the same time I'd say it's very much in my work.
I don't know how to explain that contradiction.

STEVE BROWN
(filmmaker)

Before I got tested, I thought about death just as much, if not
more. It was always in a very melodramatic way. It was the "Oh,
I've gotten this far, I'm in the prime of my youth, only to be
plucked away by AIDS" routine. And now I just think, Oh, there
will be an end, and for some reason I assume it will be peaceful.
Before I tested positive, I thought it would be the tragic snuffing
out of the candle. Now I don't fantasize about how awful it will
be to die. I just think it's one more step.

Death is a motivation now. It's something that is edging me
on. Any decisive action, any creative move, is better than none.
Death is a real impetus to move your butt and do things. It slaps
you in the face and says, "Come on, stop wasting time. Don't
worry about if this is the most brilliant film ever; don't quibble
about whether this is the best that anybody could ever do. Just
do it." What has always stopped me in the past was thinking that
something wouldn't be as good as it could. I've always been
really hard on myself. Now my attitude is, I just want to get it
done.

ROBERT FARBER
(painter)

I think about AIDS and dying and getting sick and I just hate
it. When that happens, my denial for that day is shot to hell. I got

a photograph of myself being given a vaccine at the NYU AIDS Clinical Trials Unit, taken from the back. I'm working on a piece that is going to use that image in a repeated pattern and begin to deal with some of the feelings I have about being in this trial, feelings that have changed enormously. Originally, I felt that these were people who were going to take care of me and help me. I've gotten a lot more sophisticated. I realize they care about the trial, how the trial is going. The people who don't do well in the trial are as important to the successful interpretation of the data of this trial as the people who do well. So in a way they were almost excited that I wasn't doing well. It's a real business, even though I know they are on the front lines of the fight against AIDS.

Before my T cells dropped, when I could operate with efficient denial, there was that much more distance between me and the work. But the shift now is, I'm ready to let the chips fall where they may and trust that I will find what I'm looking to express because it will be springing from a much deeper part of me, one that accepts that I'm HIV-positive and that I may die from AIDS and that before that I will probably go through a period of a year or two or three of various levels of illness and infirmity and nightmare.

In the Middle Ages, the sense of beauty was absolutely connected to considerations of mortality. They believed that earthly beauty fades and dies, so there was a very melancholy, bittersweet appreciation of that beauty. Artists used beauty to seduce the laity. Since the laity couldn't read, they learned these stories through the drawings and pictures in the frescoes. They were education tools.

I've used that as one of the elements of this new work. That seduction of visual pleasure. There's this chilling specter that I'm

trying to achieve of being drawn to the painting because it's classically beautiful and harmonious, and once in the painting, discovering that it's really about death. For instance, I have blowups on a silk screen of the crystalline form of AZT, which is incredibly beautiful and delicate and yet it's a toxic poison.

I like the way I can take different elements and put them in a particular context where they are no longer ornamental pieces of beauty but instead they take on a weightier meaning. These paintings are alluring and yet that allure draws you into a very concrete confrontation with death and mortality and the experience of illness. I like how these alluring pieces transform themselves into very moribund considerations of mortality. That's part of the kick for me. Like painting a beautiful molding black.

The fact that 1348 and the Black Death was just before the Renaissance dawned and flowered gives me hope for today. We've reached rock bottom. The only value that one cited, up until two years ago, was the bottom line. Now we have an opportunity to rediscover more human values, a rebirth of humanism very much like the Renaissance. America has always felt like we've conquered death. And I think AIDS is going to be one of the things that remind people that we're not invincible. In the face of death we'll see which values have any meaning. I think death is going to become part of our mentality. It used to be. Personally, as an artist, I got real fired up with this. I found something that for the first time in many years I could throw the full weight of my commitment behind.

KENNY O'BRIEN
(designer)

I guess I'm losing my strength. I never thought of the leather as being exhausting, but that last trip to L.A. wiped me out, dragging the jackets and showing the clothes. The jackets are heavy, the metal and leather. I took seventy-five pieces out there to show and I was so tired by the time I got to where I was staying. I have to just work slower. I cleared the land to build my house. I was chain-sawing and dropping huge trees and cutting them up and carrying them and making huge bonfires and burning. And yesterday I was wiped out just putting the fire together for the sweat lodge. You resent it. I can't do what I used to do six months ago. So either you stop doing things or you work slower. So instead of carrying three pots full of dirt and plants, I carry them one at a time. It affects the pace of your productivity. That's the thing, if you're an artist or a creative person. Like my friend Robert Orsini, who was painting with his left hand when the rest of his body was paralyzed. I mean, if you can just move a pinky you can reach out and push a key on a typewriter and write your last poem.

"Die young and stay pretty." Thank you, Debbie Harry. That was an interesting concept when that song came out. We were just rocking. We were going to be fabulous till it killed us. Cause of death: fabulousness. Who knew? We were really stampeding spiritually into such compulsivity that unless something as severe as this happened, the creative community would have just stampeded off into total disco frenzy. Studio 54 was total hedonism, but it was such a relief. As an artist you get so exhausted from trying to bring moral fiber into the culture. Finally we just said, "Fuck it!"

LARRY KRAMER
(author)

I'm going to write "The End" and then, like Proust, I'm gonna die.

LEGACY

What is the lastingness of a work, even if it endures a thousand years, compared to geological or astral ages? And yet the light or the warmth that man is capable of generating from himself in order to enliven or to move—if only for a few instants—is worth any amount of trouble. Since there is continuity, let us be optimistic.

—*Victor Vasarely*
(painter)

What does legacy mean to artists living with AIDS? Does the concept change as the illness progresses? How important is leaving a legacy for the artist, as well as for humanity?

"Leaving a legacy seems to be a necessary step," stated Jeff Friedman, a dancer and choreographer, who started Legacy, a project to preserve the oral histories of dancers from the San Francisco community. "Living here for the past ten years surrounded by people living with AIDS, I've seen the premature experience that the person with AIDS goes through of detaching the ego from the life-force. As a result, the leaving of a legacy becomes an ego-based activity where some aspect of yourself as the self is left."

How does the artist living with AIDS in a sense defy mortality by exposing

his truth in his work? What can these legacies tell us about our own truth? What can this art tell us about our own mortality?

The legacies of the artists who have already died from AIDS are astounding: canvases, photographs, journal entries, dances, plays, short stories, collages, fresh symbolism, stronger line and statements, atypical color, innovative technique. They are the works of painters, designers, writers, musicians, composers, choreographers, playwrights, philosophers—tragically the list goes on and on—who often lived the last days of their lives possessed by a creative spirit that, in many cases, didn't even seem to know they were sick.

"It would be interesting to consider what the qualitative difference is between work that is considered, by the artist, as a legacy, versus work seen as part of an ongoing creative process," continued Friedman. "In an especially ephemeral art form like dance, what is the legacy when it can't be an object? If you identify with someone who performs and that person has a terminal illness, is the legacy your internalization of some of the detachment that is happening within him? If art can provide transcendence, maybe these artists are the ultimate agents of transcendence."

Will this art eventually transcend the art world context and help us to comprehend the political, sociological, and sexual confusion of this *fin-de-siècle* period?

"Legacy is a way to understand what is going on because the emotions and impact of what we're going through right now are too large to understand in an intellectual form," stated Patrick Moore, cofounder of the Estate Project, a program in New York City aimed at encouraging a nationwide effort to preserve the works and estates of artists with AIDS. "There has to be a rawer expression of it, and art is a way that all of the feelings and memories of this time can be distilled into one object or composition. Also, legacy is a record. In the way the NAMES Project created the AIDS quilt, artists have another way of leaving a record of themselves, something personal and complete that is more than a name. Something that crystallizes their entire essence into an object."

It is probably too early to guess what effect these legacies will have on

society or even on late-twentieth-century art. "All it can do right now is to reinforce the pain we're going through," continued Moore. "We will need a cushion of time for that art to speak in a different way, one that can only come from looking back on it."

When we do look back, these legacies will provide a necessary frontline point of view that will undoubtedly broaden and enrich the scope of the history of the AIDS crisis. "A . . . hazard, built into the very nature of recorded history, is overload of the negative; the disproportionate survival of the bad side—of evil, misery, contention, and harm," wrote Barbara Tuchman. She was addressing the problems encountered compiling a history of the Black Death, but the warning is relevant to any in-depth study of a crisis or a time. "In history this is exactly the same as in the daily newspaper. The normal does not make news. History is made by the documents that survive, and these lean heavily on crisis and calamity."

How can the art coming out of the AIDS epidemic—much of which carries a positive message about a creative spirit that seems to thrive and expand in times of absolute chaos—document this time of great malaise in a way that news stories and medical papers cannot?

"The art community as a whole has to see this as *their* legacy, not just the legacies of the individual artists," Moore explained. "The arts community has to look at the standards by which they judge art and call something important. A so-called 'bad painting' may be an important historical document. If we can look at all these artists together in the context of this crisis, their legacy becomes even more important."

What impact will these legacies have on the future of twentieth-century art? On the future of the twentieth century?

MARLON RIGGS
(filmmaker)

I think about leaving a society in which the kinds of travails I had to suffer as a child and adolescent don't need to be re-

peated by others who find themselves in the same condition as I. A legacy where no other young black boy maturing has to go through the painful search for some reflection of his life in the world, and believing for most of his life that he is invisible. That even when people see him, they don't see him, because they see the mask he is forced to wear. How suffocating—not only in a metaphoric sense, but really suffocating—it was for me and so many others. I don't want to see that legacy endure.

Rather I want to bring about some world where those who find themselves different in society will realize that they have the wherewithal to assert themselves. To say no to all the legacies that have defined them as subhuman or outside humanity and to say yes to their nobility and to their difference and embrace and love it. All of my work is designed to offer that source of spiritual and psychic and cultural empowerment. Much of what has been instrumental to my own survival as a black man, as a gay man, as someone living with HIV, was a look back to see others who have gone through as severe struggles as I now face, and who have weathered them and in the process illuminated the essential nobility of our lives, the potential nobility of our lives. These people are real for me whether it's Harriet Tubman, or James Baldwin, Bayard Rustin, Malcolm X, Martin Luther King—my life is replete with such energies.

I've often said before that as a child, when I felt so utterly alone, I created friends who were historic personages. All of my work involves history; it's seldom just the moment. These personages were almost totally of my imagination. It's not like I was reading a lot of history. But I knew enough to concoct what they might be like, and it was with them that I communed to find some solace, to believe that what I was struggling through was worth it. To believe that it would reveal the essential mettle within me that would allow me to endure and to illuminate that in others.

That's what legacy means to me. It's not simply some personal individual achievement that others can look back on and say, "Wow, wasn't he a great guy," or "a brilliant guy," but rather how that life connects to and illuminates community and enables that community to survive and ultimately, hopefully, to flourish.

I see the work as strategic intervention against all of the assumptions about who we should be, who we are, and how we deal with struggles or how we don't acknowledge struggles. HIV is part of that, but again, to look at HIV in the context of so much that has decimated us or divided us from one another. And to remind people that in order for us to battle fully all that oppresses and represses us, it is necessary to engage fully with all of what that is. It's not simply white racism, it's also those internalized notions of self and community that are just as divisive and create oppression in our own communities, whether between men and women, straights and gays, the privileged and the ghetto dwellers, those who speak standard English and those who don't, those who have light-colored skin and those who are dark. That for me is creating a legacy that allows for the fullest realization of our humanity.

PAUL MONETTE
(author)

I certainly see my AIDS books and *Becoming a Man* in a legacy framework. When I started *Becoming a Man,* it was very much on my mind that I wanted to do a book about what it felt like, as early as I could remember. When I was seventeen and going to Andover, I would go to bookstores and there was nothing, nothing about being gay or lesbian. At that point, *Giovanni's Room* had been published—it's not that some marvel-

ous work wasn't available—but I couldn't somehow get to it. What I longed to read was something that would tell me what it meant to be queer. I feel a very profound sense of connective legacy to the gay and lesbian people who will follow me, and to their friends and families. I hope they somehow do "coming out" better than I did.

I want to try to show what the self-hatred is like. After a certain point you don't even need the barbs of the homophobes. You take it on yourself and hate yourself. It's not unlike the self-abusive pattern of alcoholism; the very thing you don't do when you're in the closet is talk to anyone about it. Once you start talking to people about it and meet brothers and sisters, you want to talk about it forever.

ROBERT FARBER
(painter)

I'm suddenly trying to examine my work on a much more personal level. What is the turning toward history for me? What is the moral or ethical good in exploring the similarities between the Black Death and AIDS today? What can it do? Reading these quotes from history, I saw how important it is to leave a record. I'm reading these quotes from the Black Death four hundred years later and I get their experience, not because I'm HIV-positive, but because they wrote with their hearts about what was happening around them. It's very important for me to leave a record like these people, like Petrarch and Boccaccio.

I want to be able to know that I've left some statement. I want to be able to say to the younger generation that this is what I did to do my part, to stand up and tell this story. That's a very conscious thought that floats in and out of my brain. I'm very

aware of the importance that this body of work has for me as far as what I want to be remembered for. Last Christmas was the first and only time I ever made and sent out handmade Christmas cards. I can't even call them cards; they were little paintings. They were a direct outgrowth of this work. I quoted from the duc de Berry's *Book of Hours* and I sent them out to about thirty people to whom I knew I would never be able to give major paintings. But I wanted them to have something significant of mine. And I wanted them to have it before I got sick and died.

DAVID WOJNAROWICZ
(painter)

For years I did projects that basically were fueled by the sense that I wouldn't live much longer. I don't know where that idea came from, or where that sense came from, but I would do entire photo projects with hundreds of photographs. I did this Rimbaud series when I was twenty-three, twenty-four. I was literally broke; I managed to get enough money to buy the film and I thought I would end up homeless and then die. I had no place to live. And it drove me, it drove it. I thought I had to put out this body of work, this body of communication, so that when I died within weeks, months, whatever, that people would have some understanding of this person who had passed through the world who nobody was aware of except for a couple of friends or something. It was a really intense need to communicate something or at least create something that communicated something.

RICK DARNELL
(choreographer/performance artist)

I'm concerned with leaving my community something that is useful like places to perform in. I personally started two warehouses in this city: places to make any kind of work you want. One is a punk rock warehouse and the other is a really hot performance space called 1800 Square Feet. This is my third space. We've got to have places to perform. The economy is so bad that the only things that are going to be left after this whole recession are really cool grass-roots spaces that had community support.

We're setting precedents left and right, getting money, grants. If we are touring nationally, if we can do it, anyone can do it. We're inching for art and culture, vroom, vroom, we're revving up and showing people that for fifteen hundred dollars you can take your act all the way across this country and live well. So I'm leaving behind—well, I ain't left yet—useful things. Because the pieces, well, good luck re-creating this work from videotape. It's all we can do to keep it together in rehearsals. We go back to a piece we haven't done in a year and start resetting it—nightmare!

STEVE BROWN
(filmmaker)

Having my art, having a creative outlet, lets me work out my anxieties, work out my bad feelings. You can make yourself feel better by creating something that exists independently of you. Your beliefs about the world, your opinions, you can encapsulate them and then others can look at it and see that you've made some contribution to the sum of human understanding.

PETER ADAIR
(filmmaker)

I think about leaving a legacy. I think I have. I've done a lot of films, about five or six I'm proud of, and I've always tried to live as existentially as I can. I've always tried to leave relationships in such a way that if I died the next day there wouldn't be any unfinished business, whether it's with parents or friends or enemies or whatever. I've never had a career plan. I've never said, "This is what I'm going to do." I've always done the next thing that's interested me and I've left a legacy as I've gone along. This year has been particularly good in that way. Another film which is useful, *Absolutely Positive,* is finished, and this new media game we have developed applies some humanistic storytelling and insights to a form that's been mostly dominated by people who are into spreadsheets or Nintendo.

I want to be able to change people's lives. Which I have done in my life. It's not immodest to say that *Word Is Out* has changed thousands of people's lives and I think *Absolutely Positive* helped a lot of people. So I want to be able to do that. I want to be able to make art, something that pleases me, something that advances the form. I want to be able to deal with form in the abstract. I want popular success. I want to be able to raise money. I want people to be able to see the films. I've never wanted to do films which may be very experimental and powerful and good, but have a very limited audience. I want a popular success.

BO HUSTON
(novelist)

I have a very pure writer's instinct. I want my books in the library. From very early on, I never had any expectation that I was going to be some famous, best-selling writer. I would like to feel that somebody, somewhere along the way, experienced with my writing what I have experienced with other writers. A lot of writers talk about the reader or the audience and try to envision who that may be. I know who mine is, but I'd also like to see a ten-year-old kid really being affected. So I have almost a romantic idea of a legacy. It's not about quantity or being on this or that list.

TORY DENT
(poet)

We all want to be remembered, but we really aren't. We wish that our life held more than it did, but personally, I don't think it does. If the test has made me aware of something, it's how short my life is and how important time is. And to be prepared that my life may be over at any time and to try to live my life with that sense of preciousness. I think that the dreams of immortality, of being remembered, of a legacy, it's like wishing that there were a heaven. In one poem I talk about dying and how you even hope that your friends will remember you. After a certain period of time they can't. They remember certain things they like about you. In my will, which I've written out, I want no tombstone. I would prefer to not even have a funeral, because it's a desire for permanency that life does not give us. In this poem, I say maybe there's a heaven and maybe there's a hell, but what's

for certain is that maybe I'll just end up as mulch. Why isn't that a noble ending? To me, there's a kind of egalitarian, Zen acceptance, which has comforted me rather than a hyperbolic dramatic scene of an afterlife and being remembered by my friends and my past and my work. Yes, there's someone I've asked to look after my work if something should happen to me, and try to get it published. But let's face it. How many people read poetry, anyway? Even the most famous poet, like John Ashbery, is not famous like Meryl Streep. It would be great if my work got published. It would be great if people kept reading it. But it's not something that seems realistic.

Testing positive just confirmed for me how essential it was, how deeply essential to my health it was, to write. I may never get recognized, but I will always write.

CYRIL COLLARD
(novelist/filmmaker)

Ambition, winning prizes, all that stuff is less important now. The construction of a career plan is out the window, forgotten. You live day to day. So what counts are the things you're working on now. What counts is the rapport, each day, between reality and what one does in one's art. That's what counts the most.

KENNY O'BRIEN
(designer)

Of all the artists I know who have tested positive, the first reaction, after they get the results, seems to be that everybody

stops working for a few weeks. They just digest it and go through a spiritual quandry or on a drinking binge or hop on a plane or isolate or go on a support group freakout or start reading all kinds of nutritional information and getting their AIDS posture together of how they're going to cope. And then they get back to their work. About half of them decide to just proceed where they left off. The other half decide that AIDS has to be integrated into their work. You know, I could make SILENCE = DEATH leather jackets; I chose not to do that. I started working out color combinations that I thought were very lively and vibrant. But as time went on and all the paperwork told me that I had full-blown AIDS and I started getting sicker, I suddenly realized I don't want to make clothes anymore. I want to write a book that makes a statement about AIDS and what it's like to be a person with AIDS in this culture. I want to create something that will last longer than a bunch of jeweled jackets.

REZA ABDOH
(playwright/director)

The memory that I would like to be retained of me is of somebody who tried to voice in some way what was inside him; even if he failed, he tried.

ESSEX HEMPHILL
(poet)

I've always been writing for the long haul. I've always recognized that literature has a power I've wanted to learn to manipulate and control to be able to represent what I experience and see as true. When I think of legacy, perhaps I just accelerated

that sense of the long haul. Accelerated it to the extent that I'm trying to be even more disciplined about my work to insure that I construct it in a way that allows it to have an even longer life. If it means that I beat and beat and beat a poem now, it could be the last poem, but it's got to be able to last longer than anything I might have envisioned. At least as long as there is a planet and there is the possibility of free access to literature and whatnot. All of that's questionable, because when I think of being HIV-positive I think not only in terms of my being a black male, I think of it in terms of the environment, in terms of the world we live in and will there be a world? Legacy for me is most surely endowed with the sense that my work has to at least speak of the power of candor, the power of telling our truths and telling them with confidence, and telling them in the language that we know them in. That's what I hope the body of the work will say; that's what I continue to force from myself, as I deal more and more publicly with being HIV-positive.

KEITH HARING
(painter)

Nothing is trivial. I wish I didn't have to sleep. But otherwise it's all fun. It's all part of the game. There's one last thing in my head. With the thought of—of summing up. My last show in New York felt like it had to be the best painting that I could do. To show everything I have learned about painting. The thing about the projects I'm working on now—a wall in a hospital or new paintings—is that there is a certain sense of summing up in them. Everything I do now is a chance to put a—a crown on the whole thing. It adds another kind of intensity to the work that I do now; it's one of the good things to come from being sick.

If you're writing a story, you can sort of ramble on and go

in a lot of directions at once, but when you are getting to the end of the story, you have to start pointing all the things toward one thing. That's the point where I'm at now: not knowing where it stops but knowing how important it is to do it now. The whole thing is getting much more articulate. In a way it's really liberating.

EPILOGUE

Will the film have a happy ending?

Kenny O'Brien died that summer, a couple of months after I drove upstate to interview him. I sent his family the tapes of our conversations; I heard they played parts at his memorial service. I often think about the night we talked on his balcony overlooking the valley. The night he told me all the things he still had left to do.

Around Christmas, Hervé Guibert died in Paris. The documentary he made about living with AIDS had aired on French television a few months before. Guibert became a celebrity in France and helped put a face on this disease there. His portrait, sunken cheeks and piercing eyes, peered from bookstore windows on the cover of *Le Protocole Compassionnel,* the novel he based on his relationship with his female doctor.

Also in Paris, Cyril Collard was busy finishing the film *Les Nuits Fauves,* adapted from his novel. Collard ended up playing the lead role himself when he couldn't find the right actor to portray his HIV-positive protagonist. Will the film, as Collard told me in our interview, have a happy ending? A double happy ending, he called it.

In Los Angeles, one night that winter, I ran into Dennis Cooper, who said that David Wojnarowicz was very sick. I brushed his words away. "It's like that, this disease," I said, trying hard to be optimistic, not wanting to hear what he was telling me. "I've seen so many artists living with AIDS, thought they wouldn't make it, next thing they're working again." Cooper shook his

head, shrugged. I called David, at his loft on New York's Lower East Side, heard his voice on the machine. A month later, in an art magazine, I read his words: "I'm a glass human disappearing in rain." It was an essay from his new book. He was writing, still working. Now he too is gone.

What will we do without Wojnarowicz's voice, so loud and angry? Without his powerful words and images of death and disintegration?

Will the film have a happy ending?

One week, I heard of two important art shows about AIDS—a traveling exhibition called *Media and Metaphors* and another that will include work in various disciplines done solely by artists who are HIV-positive or who have AIDS. Is this a sign that more artists are engaging openly in the discussion about AIDS? The same week, on the front page of the *New York Times,* a group of experts compiled horrifying statistics stating that, by the year 2000, between 40 and 110 million people worldwide will be infected by the HIV virus.

We need an ongoing dialogue about AIDS and the surrounding issues; maybe now the time is right. Five years ago, I never would have written this book. Five years ago, I thought this disease would come and go and be forgotten. Five years ago, I had five friends who knew they were HIV-positive, four men and a woman. Today I can't even count how many I know.

When I started writing this book, I searched hard to find artists who would come out about their medical status, who would take the risk and speak openly about highly charged political and personal issues. Now, even as I write the final words, more artists come forward. They, too, want to tell their stories. They, too, need to be heard.

Maybe college art departments will follow the example of Yale and teach courses on AIDS and its representations. Maybe they will develop new courses. Maybe, one day soon, when an artist, or anyone, finds out he is HIV-positive, he will have source material to refer to that will bring him closer to others in the same situation, that might help him not feel so alone. Images and words that can unite him with others who, like himself, are not dying but

living. Maybe, one day soon, there will be new images to superimpose on the current media image of AIDS, the image of an emaciated man, death mask in place, lying in a hospital bed. Images of strong and vibrant men and women, creative men and women, for whom AIDS has become an inspiration and a driving force.

Will the film have a happy ending?

Patrick O'Connell called the other day and told me that his T cells had dropped. Then he asked me to come over and cut red ribbons. Robert Farber faxed me a note: "Things are going well—in general. Now if I could only get my T cells to behave. They dropped another 60 points to 178. When I found out yesterday, I was a mess but already this morning I'm feeling better. Actually it's a tribute to the human spirit—how we learn to adjust." Then he listed three new shows of his paintings that have been confirmed for this year.

I take the phone numbers of the artists who contact me, artists from all over the United States, from all over the world. I tell them that I have decided to make a documentary about AIDS, artists, and art. I ask them if they think people are ready to see the faces and bodies behind the words. I ask myself:

Will the film have a happy ending?

Everyone I interviewed for this book was a warrior. Every soul I met was on the hero's path. Everyone I talked with was, in Nietzsche's words, up to his destiny.

I hope I have been up to mine.

In facing this crisis, I hope we are all up to ours.

So let the sun remain behind me!

—*Goethe*
Faust

ACKNOWLEDGMENTS

From the conception of this project over two years ago, I have been nurtured by the encouragement and support of many people. I want to express my gratitude and appreciation to some of them here.

One of the first people I interviewed was Visual AIDS's indomitable Patrick O'Connell. I want to thank him for so often pointing me in the right directions and for his extensive Rolodex. I want to thank Jeff Friedman, who created Legacy and who introduced me to many people in the San Francisco arts community. I would also like to thank Lesley Farlow and the New York Public Library for the Performing Arts for access to interviews with Demian Acquavella, Burton Taylor, Tim Wengerd, and Arnie Zane from the Dance Collection's Oral History Project.

Although I spent invaluable hours listening to some of the most powerful artistic voices of our time, others had already fallen silent by the time I picked up my pen to tell this story. Fortunately, their words were recorded elsewhere and I was able to use pertinent quotes in this book. I want to thank *Rolling Stone* magazine for the August 10, 1989, interview with Keith Haring; *Art News* (December 1988), *Flash Art*, and *Esquire* (September 1989) for interviews with Robert Mapplethorpe; *7 à Paris* for the April 24, 1991, interview with Hervé Guibert; and *City Lights Review* for publishing Cookie Mueller's last letter. David Wojnarowicz and I spoke on many occasions, but I also chose to include two passages from his book *Close to the Knives*.

I would like to thank all the people I interviewed who helped me reach a better understanding of a particular artist's work: Robert Atkins, Robert Berman, Irene Borger, Dennis Cooper, Richard Duardo, Elsa Flores, Fay Gold, Nan Goldin, Alexander Grey, Anna Halprin, David Hockney, Bill T. Jones, Patrick Moore, Herb Ritts, Charlie Scheips, Jan Turner, and Joy Silverman.

My heartfelt thanks to David Mills, Dana Plank, and Doug Balding from *Areté* for encouraging and publishing "Eros, c'est la mort," my original story on AIDS and the artist.

I want to thank Star Black, Aloma Ichinose, and John Mastromonaco for their brilliant photographs.

Thanks and love to my friend and mentor Shelley List for sharing her secrets, and to my friends Joan Frosh, Diane Connors, and Katherine Braun for believing.

All my gratitude to the Monday night gang for daring to explore the writing life.

I want to thank Ed Sedarbaum, who is so much more than a copy editor, who made a usually tedious process lots of fun, and who added yet another dimension to the work.

All my thanks to everyone—literally everyone—at Grove Press for their enthusiasm and support, and to my agent, Loretta Barrett, who seized this project, championed it staunchly, and helped shape it.

There are no words deep enough to convey the gratitude I feel toward Jim Moser, my editor, the man destined to edit this material. Knowing he was there to reel me back in toward our mutual vision of what this book could be, I had total freedom as a writer to explore creatively any direction I chose. Thank you for your patience, Jim, and for keeping me pure and honest. I never could have written this book without you.

. . . And to all the artists who have made their words available in the hope that they will help and inspire others, there are no words strong enough to thank you for sharing parts of your lives with me.

ABOUT
THE ARTISTS

REZA ABDOH *(playwright/director)* has written and staged many plays worldwide, including *Minimata, The Hip Hop Waltz of Eurydice,* and *Bogeyman.* He was born in Tehran and educated in England and Los Angeles.

PETER ADAIR *(filmmaker)* has been making documentaries, including *Holy Ghost People, Word Is Out,* and *Absolutely Positive,* for over thirty years. He is now writing a feature.

STEVE BROWN *(filmmaker)* wrote and directed many short films, including *The Perfect Couple* and *The Joneses.* He also writes and directs music videos.

CYRIL COLLARD *(novelist/filmmaker)* is the author of *Condamné Amour* and *Les Nuits Fauves.* He recently wrote, directed, and starred in a film adapted from the latter. He lives in Paris.

RICK DARNELL *(choreographer/performance artist)* is the artistic director of The High Risk Group. He established 1800 Square Feet, a San Francisco performance space.

TORY DENT *(poet)* is the author of four books of poetry. Her poems have been published in journals including the *Paris Review* and *Partisan Review,* and her art criticism has appeared in *Artscribe, Arts,* and *Flash Art.*

ROBERT FARBER *(painter)* has work in major private and museum collections. He recently showed his *Western Blot* series of paintings at Artists Space in New York, Tramways in Glasgow, and the Art Institute of Chicago.

HERVÉ GUIBERT *(novelist)* wrote more than fifteen books, including *A l'ami qui ne m'a pas sauvé la vie* and *Le Protocole Compassionnel.* He lived in Paris until his death in December 1991.

KEITH HARING *(painter)* began his career as a graffiti artist. His work is in major modern art museums and private collections around the world. He also designed stage sets, painted murals, conceived a line of attire and accessories, and illustrated numerous texts. He died in February 1990.

ESSEX HEMPHILL *(poet)* is the author of three books of poetry, including *Ceremonies.* He is the editor of *Brother to Brother: New Writing by Black Gay Men* and has participated in the films *Looking for Langston* and Marlon Riggs's *Tongues Untied.*

BO HUSTON *(novelist)* is the author of *Remember Me, Horse and Other Stories,* and *The Dream Life.* He is a columnist for the *San Francisco Bay Guardian.*

LARRY KRAMER *(author)* wrote the plays *The Normal Heart* and *The Destiny of Me* and the novel *Faggots.* He was nominated for an Academy Award for his film adaptation of D. H. Lawrence's *Women in Love,* which he also produced.

ROBERT MAPPLETHORPE *(photographer)* has pictures in major museums and galleries around the world. The Mapple-

thorpe Foundation supports AIDS research and funds photography-related projects through museums and other institutions. He died in March 1989.

JAMIE McHUGH *(dancer)* conducts dance and creative process workshops and works as a movement therapist with people with life-threatening illnesses.

PAUL MONETTE *(author)* has written six books, including *Borrowed Time: An AIDS Memoir, Afterlife, Halfway Home,* and *Becoming a Man: Half a Life Story.*

COOKIE MUELLER *(writer/actress)* is the author of *Walking through Clear Water in a Pool Painted Black* and *Putti's Pudding,* a book of drawings by her husband, Vittorio Scarpati, who also died of AIDS. She was the art critic for *Details* magazine. She died in November 1989.

KENNY O'BRIEN *(designer)* pioneered the use of metal and crystal studs on leather clothing. His one-of-a-kind designs and commisions are owned by many international entertainers. He died in August 1991.

MARLON RIGGS *(filmmaker)* won an Emmy Award for his documentary *Ethnic Notions.* His other films include *Tongues Untied, Color Adjustment, Je Ne Regrette Rien (No Regrets),* and *Black Is . . . Black Ain't.*

PHILIP JUSTIN SMITH *(playwright/performer)* founded the modern dance company White Dance. He has appeared in productions at San Francisco Repertory, Theater Rhinoceros, and Theatre Artaud. He died in September 1992.

BURTON TAYLOR *(dancer)* danced with the Joffrey Ballet. He wrote dance-related features for many publications, including the *New York Times* and *Dance Magazine*. He died in February 1991.

TIM WENGERD *(dancer)* was a soloist with Martha Graham's company. He worked with Anna Sokolow and danced with the Repertory Dance Company. He died in September 1989.

EDMUND WHITE *(novelist)* is the author of many novels, including *A Boy's Own Story, Forgetting Elena,* and *The Beautiful Room Is Empty.* He is working on a biography of Jean Genet.

DAVID WOJNAROWICZ *(painter)* had solo exhibitions worldwide and his work is included in many museum collections. He also made films, recordings, and performance art and authored two books, *Close to the Knives: A Memoir of Disintegration* and *Memories That Smell like Gasoline.* He died in August 1992.

ARNIE ZANE *(choreographer)* danced in many of the pieces he created for the modern dance company Bill T. Jones/Arnie Zane and Company, which he founded with Bill T. Jones. Some of his compositions include *The Gift/No God Logic, The White Night Riot,* and *Prejudice.* He died in March 1988.